T0272643

DESTINATION WELLNESS

THE 35 BEST PLACES IN THE WORLD

TO TAKE TIME OUT

JONGLEZ PUBLISHING

Among the questions I get asked most often, right after 'What's the most effective anti-wrinkle cream of the moment?', is 'I really need a break. You know me: where should I go?' So I advise my hairdresser, who's a fan of bootcamps and sunshine, to go to a cutting-edge holistic centre in Bodrum; I tell my best friend and her surfer husband to sign up for a surf and yoga course in Taghazout; as for my CEO buddy who's running out of steam, I recommend a fasting retreat in Brittany; and I suggest that my yoga teacher, who's tried just about everything, should go on a silent retreat in a secret community in Sri Lanka.

Over the years, working as a journalist at *Le Figaro* (where I oversaw the beauty and wellness section), on my personal travels (particularly in Asia and the United States) and through my various encounters along the way (experts, other journalists, press officers, etc.), I've been able to build up a precious address book of 'disconnect destinations'.

When Thomas Jonglez, the founder of the eponymous publishing house, suggested publishing a guide dedicated to the topic, I immediately wanted to write it with him. These days, who doesn't need to disconnect in order to better rediscover themselves? Thomas had a

few of his own very secret and unusual destinations (his speciality!) to suggest. All the addresses we're unveiling today have been tried, tested and validated. From the most New Age destination to the most medicalised approach, from the most unsophisticated retreat to the most luxurious getaway, for every budget (from €20 a night to €20,000 a week) and every motive (detox, sport, nature, spirituality ...), there's something here for everyone.

Ironically, as you flip through these pages, you'll discover that wellness is not a destination but a journey. These retreats are not designed for sunbathing by the pool, but for learning, delving deep inside yourself and (re)discovering the tools you have in your toolbox. As with the video wellness retreats I have created, inspired by my experiences at retreats around the world and which you can enjoy from the privacy of your own home, I have tried to add some broader avenues for reflection throughout this book. I want to show you that it's possible to take a break from it all, pamper yourself and reconnect with your true self without having to go to the ends of the earth.

I hope you'll enjoy the (inner) journey!

<div align="right">Émilie Veyretout</div>

CONTENTS

MII AMO

ARIZONA, USA

MEDITATING
IN A VORTEX

Mii amo might not be as large or as famous as Canyon Ranch or Miraval in Tucson (it has 23 rooms) but that doesn't make it any less of a noteworthy wellness destination in Arizona. Its name comes from an Indigenous American term meaning 'one's path' or 'one's journey': its various programmes, ranging between three, four, seven and ten nights, are called journeys.

From the windows of the rooms, the pool and the spa (all freshly renovated), your eyes will inevitably be drawn to the incredible red rocks surrounding the facilities – they set the tone of your stay. Mii amo is located in one of the ten most powerful energy vortexes on the planet.

 MII AMO

+1 844-993-9518 miiamo.com

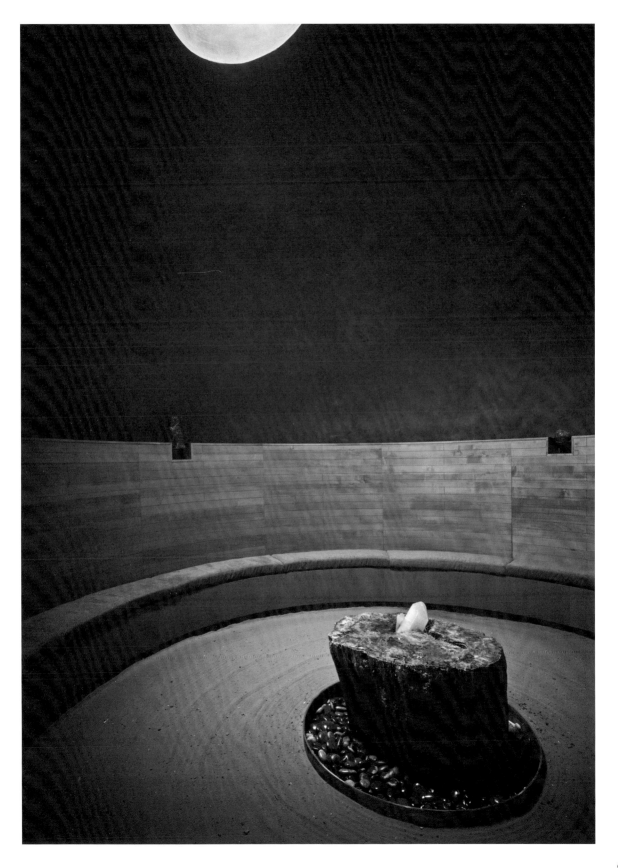

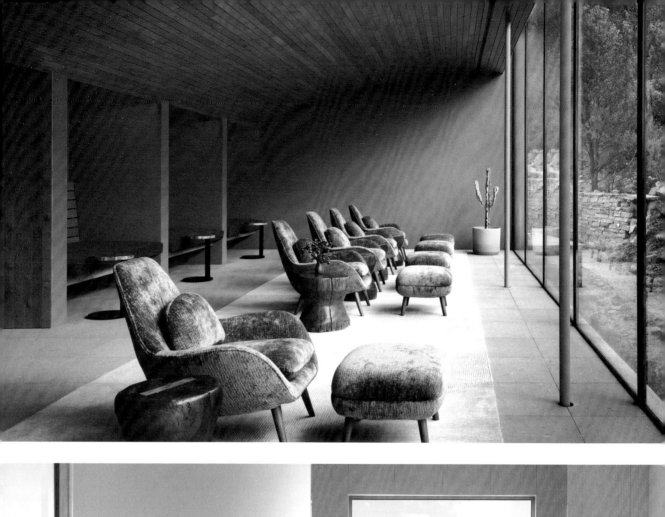

Have you ever found yourself in a place where you felt as if the Earth's energy was heightened? That's because you were in a vortex, a place where energy is stronger and more concentrated than anywhere else. These places are particularly conducive to meditation, prayer and spiritual healing.

The Boynton Canyon Vortex is what has made Sedona famous and it continues to delight visitors coming to Mii amo.

On arrival, each guest meets their personal guide to co-create their own menu of experience. The focus is on discovering inner power and selecting various treatments, meditation sessions and activities on an all-inclusive basis (around €1,200 a night).

The spa's focal point is undoubtedly the Crystal Grotto, a stunning space where participants gather for guided meditations and other group activities. Here, you can learn how to set an intention, experience and communicate with greater compassion, create a tree of life, balance your chakras, reconnect with the spirit of nature, meditate while walking through a labyrinth-like garden or admire the sky at nightfall. You can also enjoy massages (stone, Reiki, couples massages ...), take sports classes, hike, create beaded bracelets or paint

A vortex is a place where the concentration of energy is stronger than elsewhere – it is conducive to meditation, prayer and spiritual healing.

On the website, readings, sound baths and meditations (on the themes of gratitude, inspiration, abundance, letting go ...) are available to continue (or discover) the Mii amo experience from home (click 'Mii Time' in the dropdown menu for free access).

© KEN HAYDEN PHOTOGRAPHY

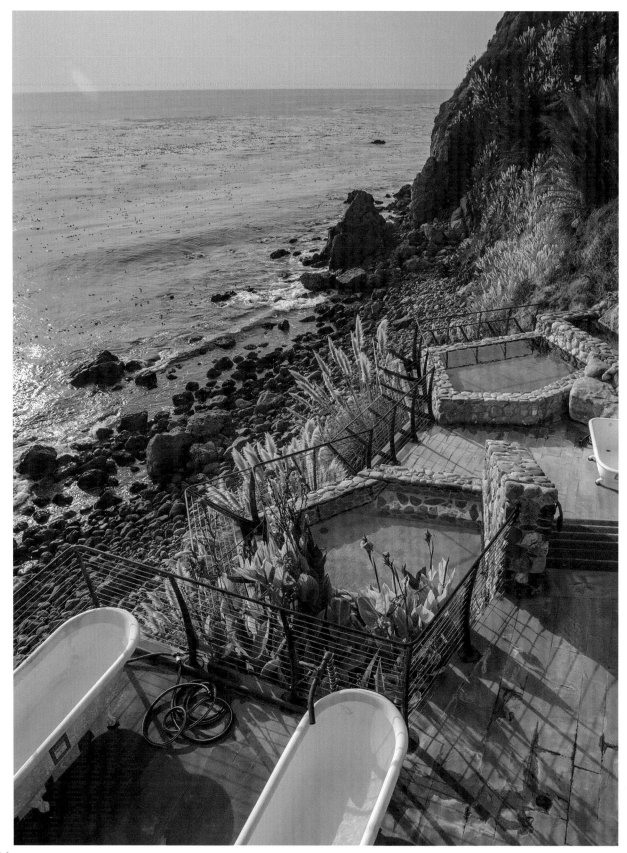

CALIFORNIA'S
NEW AGE TEMPLE

Set in the heart of California's quieter, less 'sophisticated' region, the Esalen Institute – named after a tribe of Indigenous Americans who once bathed in the local sulphurous hot springs to purify themselves – has fascinated generations of inner peace-seekers since the 1960s.

Perched on the spectacular cliffs of Big Sur, on the shores of the Pacific Ocean, this retreat and study centre was founded in 1962 by two young hippies from Stanford who wanted to explore human potential. It quickly became a mecca for personal development.

From Gestalt therapy to holotropic breathing, bioenergy, shamanism, psychedelic plants and more, its avant-garde research into new therapies, spirituality and the psyche has made it America's New Age incubator and a haven for artists, intellectuals and researchers coming to explore the mysteries of shamanic cosmology and extraterrestrial intelligence.

 ESALEN INSTITUTE

+1 831 667 3000

esalen.org
info@esalen.org

The Esalen Institute has welcomed counterculture's biggest names – think Bob Dylan, Deepak Chopra, Henry Miller and Anaïs Nin – which explains why you have to wait several months before you can book a stay. It remains a reference today. Every year, the teaching institute and holistic retreat offer over 500 workshops on the theme of transformation to some 20,000 visiting professionals and individuals.

No cameras are allowed and it's no accident that the internet and phone signals are weak. Although it's not necessarily one of the themes addressed, a digital detox is highly recommended.

Expect spartan conditions in the attractive brick motel (which once housed the convicts who built the nearby road). Between the wooden pavilions given over to workshops, the yurts scattered across the 2,000-hectare property and the dizzying schedule of activities, it's easy to get lost. On offer are courses in gratitude, mindfulness, holotropic breathing, Reiki and Tantra, but also talking circles, herbalism, making creams, group dancing under the full moon, as well as methods based on technology and neuroscientific innovations such as EFT (emotional freedom technique) and EMDR (eye movement desensitisation and reprocessing).

The staff make a point of reminding you that even in the world of wellbeing, you mustn't give in to FOMO (Fear Of Missing Out), which is an enormous source of anxiety.

Unlike other centres that encourage you to 'enjoy the journey', at Esalen wellbeing is the intended destination. The point of coming here is to be more in tune with yourself when you leave … more conscious, clearer-headed, more creative and more effective.

For all these reasons, and perhaps also because its management has been entrusted to a former Google executive, Esalen is now the preferred holiday destination for Silicon Valley executives.

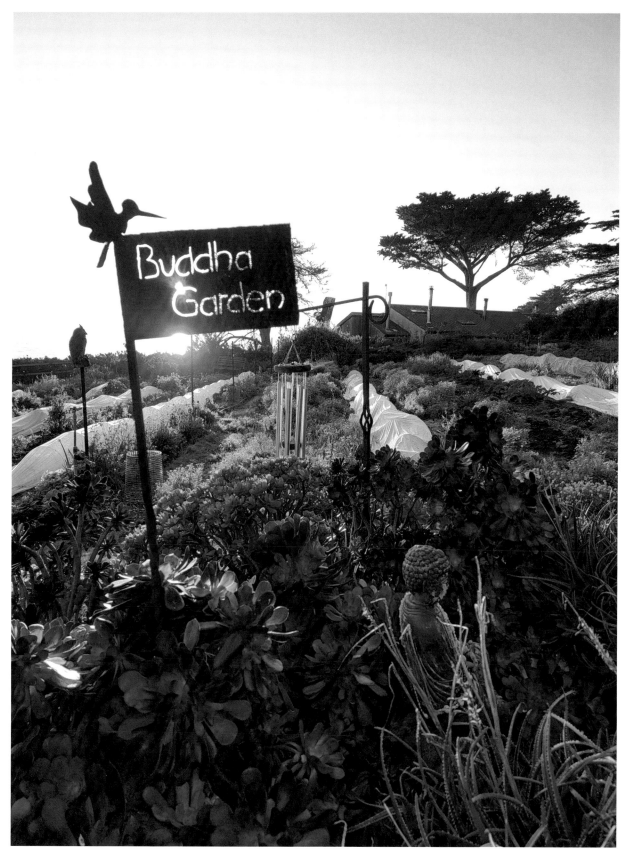

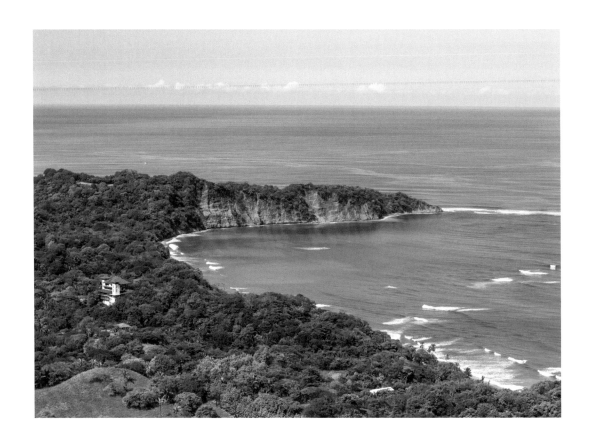

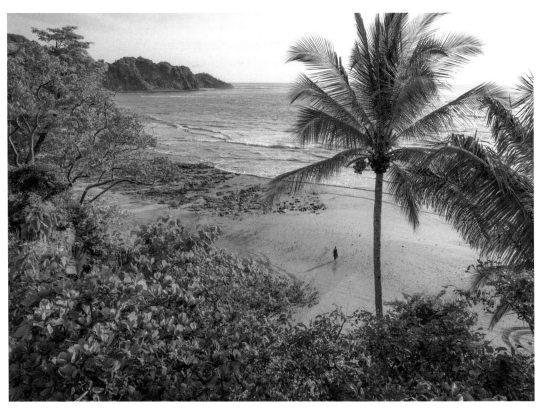

BLUE SPIRIT

COSTA RICA

IDYLLIC SURROUNDINGS FOR AN INNER TRANSFORMATION

With its primary forests, exceptional wealth of animal life and immaculate beaches, Costa Rica is a pioneer of environmental sustainability and is often listed as one of the happiest and most peaceful countries on Earth. It's a wellness destination in itself!

Locals and tourists live the *pura vida* (which can be loosely translated as the 'simple life') by adopting a healthy lifestyle, aligning their food habits with nature and living in harmony with the elements. While outdoor activities used to be the main focus – think jungle trekking, white-water rafting or yoga at sunset – some hotels are now adding advanced holistic programmes to the list.

 **BLUE SPIRIT
COSTA RICA**

+506 2656 8300

bluespiritcostarica.com
info@bluespiritcostarica.com

This is the case of Blue Spirit, a vibrantly energetic retreat centre perched on a hill overlooking the Pacific Ocean and a white sand beach that is protected as a refuge for turtles.

For anyone dedicated to their personal development and wanting to align their life with the natural world, this retreat is set in extraordinary surroundings. The founders – Stephan Rechtschaffen, a medical doctor, and his partner Annette Knopp, a healer and trauma therapist – created this retreat focused on spiritual transformation.

The Nicoya peninsula is among the five regions of the world (along with the island of Sardinia, the Greek island of Icaria, Okinawa in Japan, and Loma Linda in California) where people live the longest.

The programmes are centred around yoga, meditation and ecstatic chanting (world-renowned artists such as Krishna Das and Deva Primal & Miten are regular guests). The 'intensive weeks' (focusing on mindfulness, therapeutic writing, lucid dreaming, nutrition and more) attract both experienced professionals and newcomers looking for a better life.

Retreats generally last for seven days and the thematic programmes are shared in advance on the website. With accommodation ranging from tent to cottage to suite, there are options for every budget.

All-vegetarian cuisine and a holistic spa (Reiki, Chi Nei Tsang abdominal massage of the internal organs, chakra harmonisation, etc.) complete the experience.

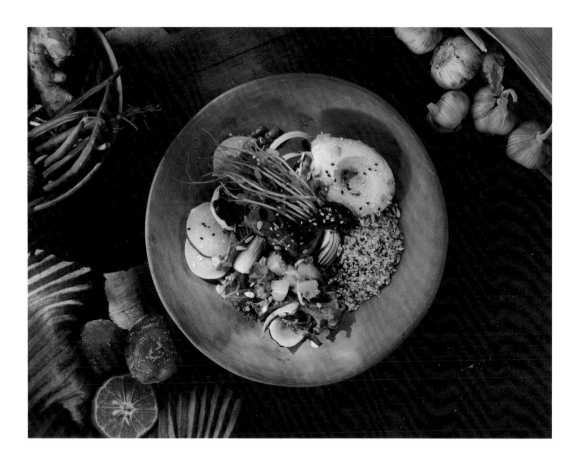

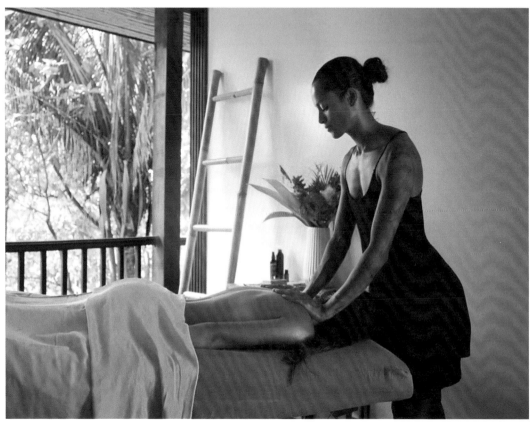

FINDING YOUR BALANCE
AT A FINCA IN PUERTO RICO

Just a stone's throw from the main island of Puerto Rico in the Caribbean, the island of Vieques was given a new lease of life when the Finca Victoria Hotel was transformed into an Ayurvedic retreat.

With its wooden bungalows, lush greenery, picture-postcard sunsets and stunning views of the Milky Way at night (there is very little visual pollution here), all that was missing was a wellness retreat worthy of the name to make this enchanting island, located south-east of Puerto Rico, an ideal destination to reset body, mind and soul.

FINCA VICTORIA

finca-victoria.com | info@lafinca.com

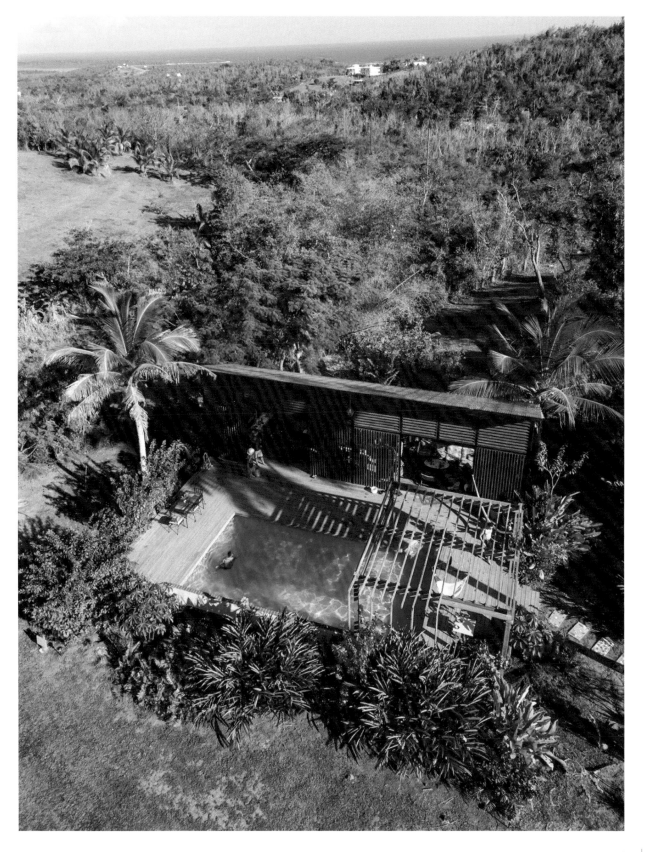

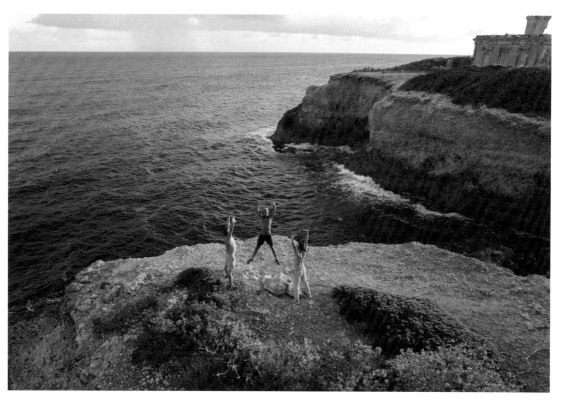

Days start with coffee or tea in bed, a complimentary morning yoga class followed by a fresh vegan and Ayurvedic breakfast before a treatment or just a dip in the freshwater pool. The rooms are all different, rather minimalist – we recommend choosing a tree suite for an exceptional view. They're all equipped with a hammock, and not just for aesthetic reasons: it's been proven that the rocking of a hammock relieves pressure points on the spine and has a calming effect on the nervous system by reducing levels of cortisol, the stress hormone.

The menu at the Finca Victoria changes with the seasons and guest teachers (often from the US) organise retreats here: Ayurvedic therapies, massage using local plants, Chinese medicine, Janzu (water therapy), mindfulness, yogic retreats and so on.

One week a month is devoted to the Panchakarma detox programme during which a whole group commits itself to a purification process that combines Ayurvedic treatments, yoga and talking circles. The collective energy that emerges multiplies the individual effects tenfold: in ancient civilisations, the community cared for its members.

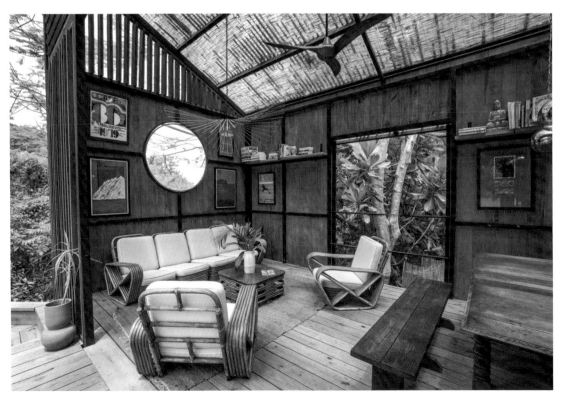

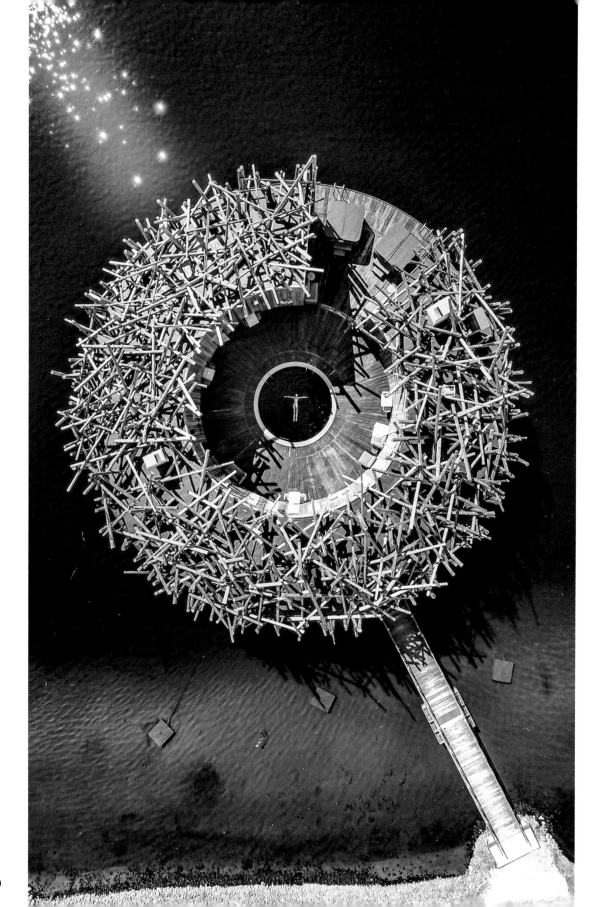

DIVING
IN THE ARCTIC

The health benefits of ice baths are well documented: they release feel-good hormones, relieve nervous tension and boost immunity and self-confidence. This is the secret to the longevity of many peoples of the Northern Hemisphere, including the Swedes, who turned this ancestral practice into a national way of life and a booming tourist attraction long before the much-publicised Wim Hof.

ARCTIC BATH

+46 928 70 30 40

arcticbath.se
booking@articbath.se

In Swedish Lapland, Arctic Bath is an ecological hotel floating on the River Lule that offers visitors the chance to discover these famous local traditions and brave the icy waters of the Arctic. To do this, the hotel has dug a huge open-air ice bath at its centre into which the bravest guests can plunge before warming up in the nearby saunas and thermal baths.

Alongside its invigorating baths and spa, the hotel offers a whole range of activities that are as unusual as they are fun and will appeal to every member of the family: snowmobile tours, dog-sledding excursions, cross-country skiing, an introduction to ice fishing, outdoor yoga classes …

The hotel's twelve cabins and suites (six floating and six on shore) offer breathtaking views of the northern lights in winter and the midnight sun in summer.

This is a retreat like no other, where fans of Nordic bathing, new experiences and being in communion with nature will enjoy long-lasting regenerative benefits.

Beyond the varied programme of activities, being immersed in the heart of Europe's wildest region, as close as possible to the Arctic Circle, is an integral part of the holistic experience, and an unforgettable one at that.

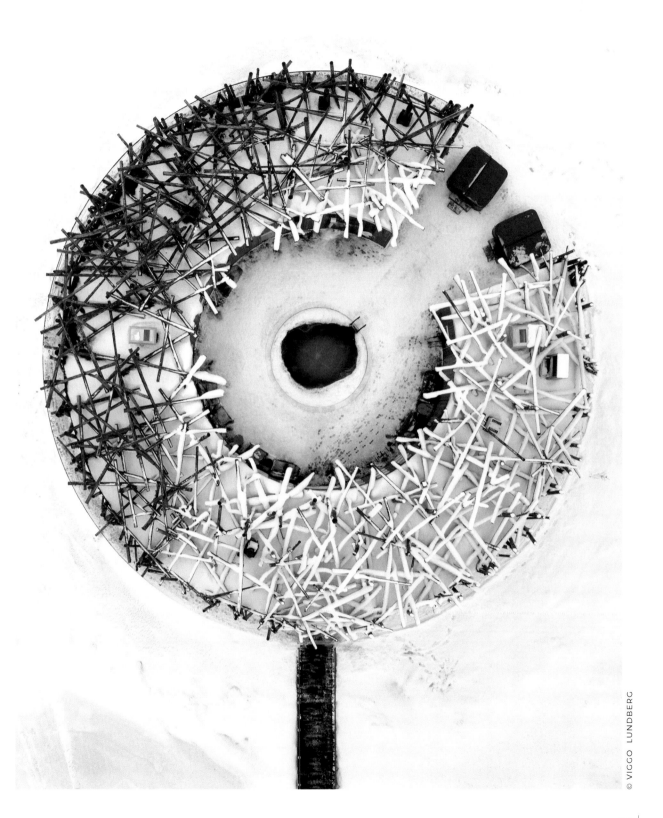

© VIGGO LUNDBERG

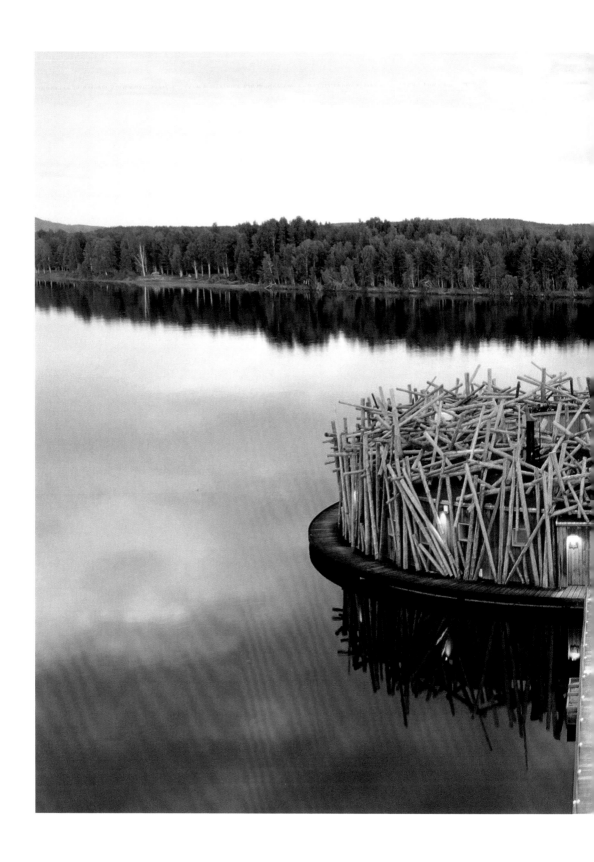

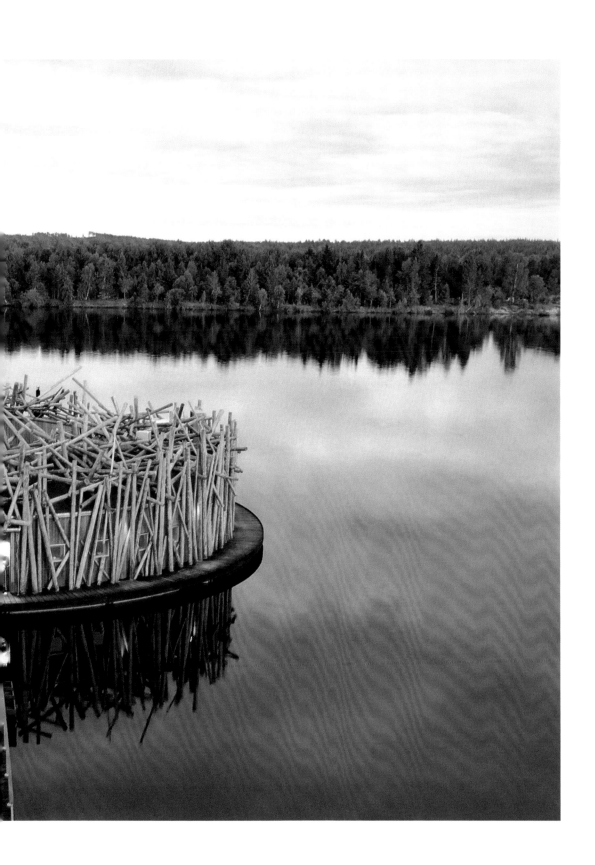

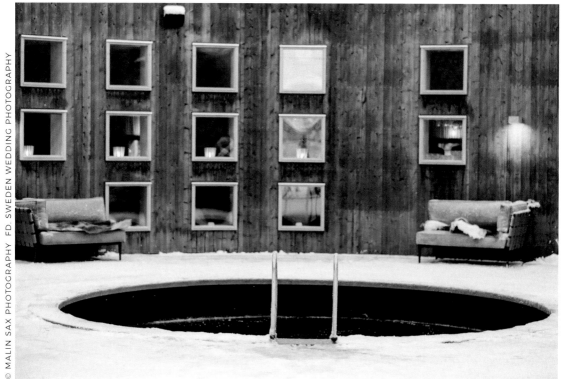

© MALIN SAX PHOTOGRAPHY FD. SWEDEN WEDDING PHOTOGRAPHY

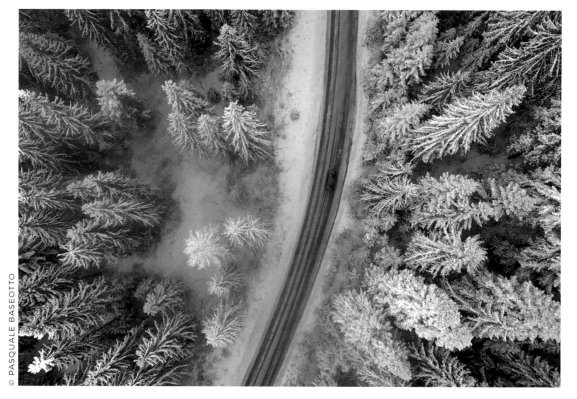

© PASQUALE BASEOTTO

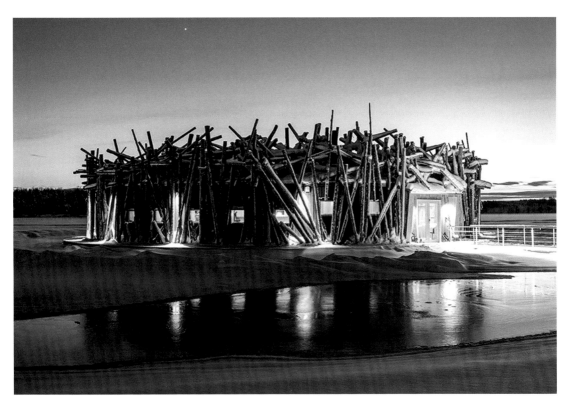

THE TEMPLE
OF FASTING

Overlooking Lake Constance, the Buchinger Wilhelmi clinic remains the go-to-place for fasting purists, who have dubbed it 'the temple'. For at least ten days, celebrities and strangers cross paths and support each other.

The clinic was founded more than a century ago by Otto Buchinger. Buchinger, who suffered from severe polyarthritis, was unable to find a cure through conventional medicine and decided to embark on a nineteen-day fast in the hope of alleviating the pain. Once cured, this nature and personal-development enthusiast decided to devote his life to devising a medical therapy centred around fasting.

**BUCHINGER
WILHELMI**

+49 7551 8070

buchinger-wilhelmi.com

© WINFRIED HEINZE

© WINFRIED HEINZE

© WINFRIED HEINZE

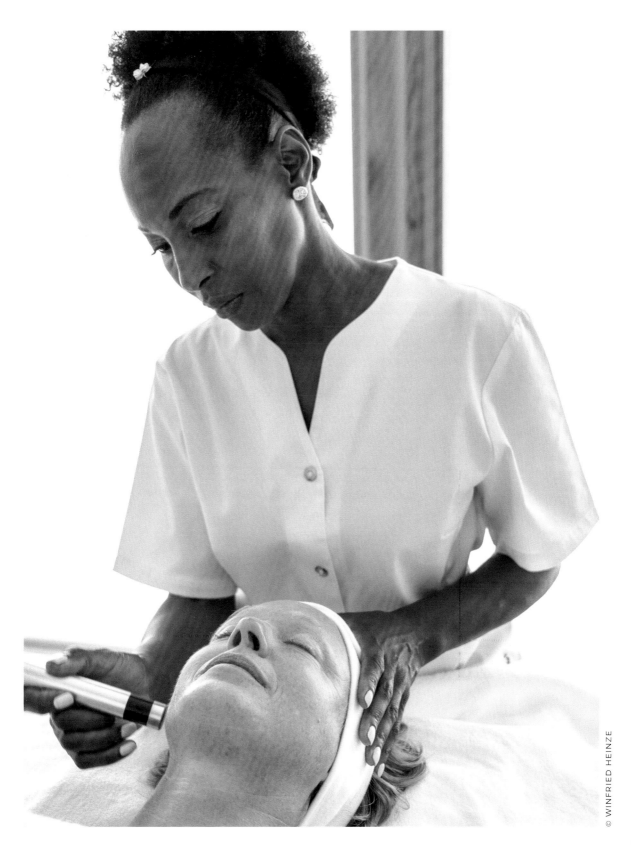

© WINFRIED HEINZE

© B.LATERAL GMBH&&CO.KG IWH

Today, the clinic is run by his great-grandchildren and the original programme, now backed up by the latest academic research, is still based around its three founding pillars: medicine, spirit and community.

There are no unnecessary luxuries here, and the rooms are basic with small single beds, but a team of specialist doctors (diabetologist, rheumatologist, hepatologist ...) and nurses are on hand 24 hours a day to provide precise medical monitoring. This makes the clinic an essential setting for those suffering from a chronic illness or seeking treatment for a pathology (as is the case of many patients at Buchinger Wilhemi).

After a first day dedicated to dietary transition, a blood test and an intestinal cleansing (with the help of a laxative), patients drink only water (lots of it, fresh or in the form of herbal teas), a fruit and vegetable juice at lunchtime and a broth in the evening. A light calorie intake (around 250 kcal) is designed to reduce side effects such as headaches when the metabolism goes into ketosis (when the body starts to transform its fats).

'During a fast, the body is fine. It's the soul that feels the hunger.'

After this, the feeling of hunger disappears, energy bounces back and certain existential or emotional blockages can reveal themselves (sometimes through astonishing dreams). That's why, in addition to an extensive list of activities (yoga, Tai chi, hiking, massage, body wraps, Ayurvedic consultations, etc.), the clinic also provides psychologists, round-table discussions on psychosomatics, and 'spiritual nourishment' in the form of concerts, art classes and literary discussions. As Buchinger once said: 'During a fast, the body is fine, it's the soul that feels the hunger.'

At the end of the ten days, patients gradually resume eating, a fundamental stage in the process.

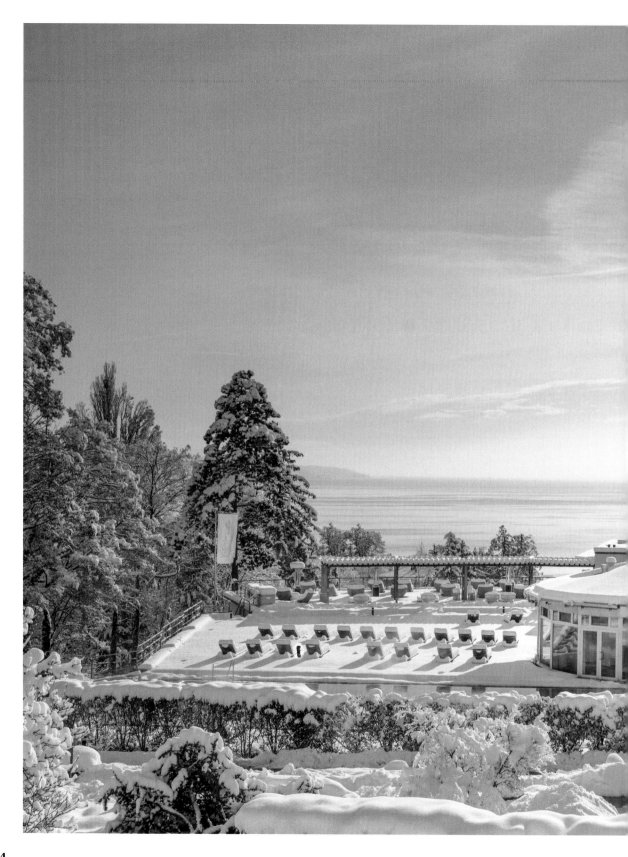

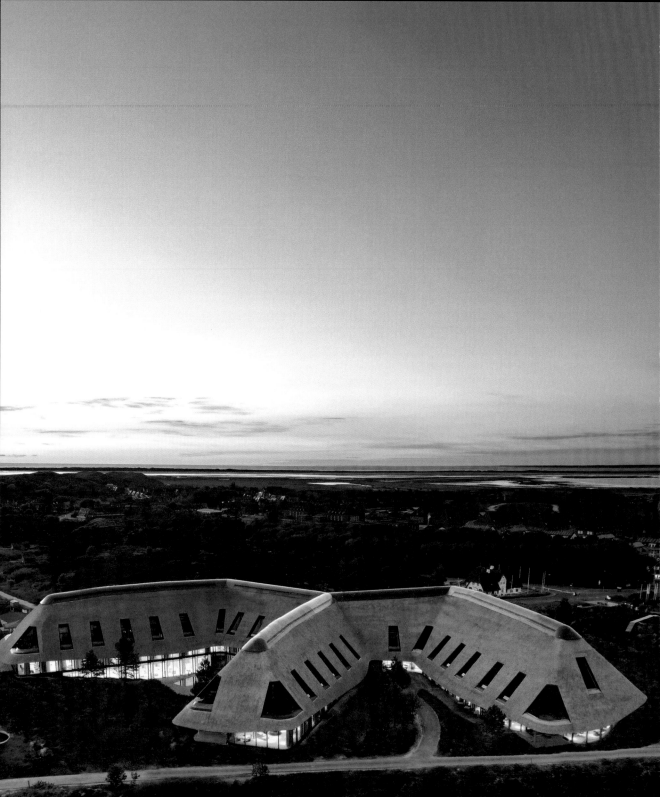

LANSERHOF

SYLT, GERMANY

AN ULTRA-TRENDY
DIET

Is it their influencer strategy, their breathtaking architecture, their successful marketing or the quality of their treatments? Undoubtedly, it's a little of each.

Lately, the Lanserhof group have gained an edge. From Lans in Austria to Tegernsee in Germany, their clinics are the talk of the town. Their latest addition is located on the island of Sylt, a sort of 'Hamptons of Germany' where top CEOs, intellectuals and celebrities come to relax in total discretion on the shores of the Wadden Sea on the border with Denmark.

The impressive complex stands on the dunes and features 20,000 m² of seamless design built around an immense circular staircase, with 68 rooms and 5,000 m² devoted to treatments.

 LANSERHOF

+49 4651 9959570

lanserhof.com
info.sylt@lanserhof.com

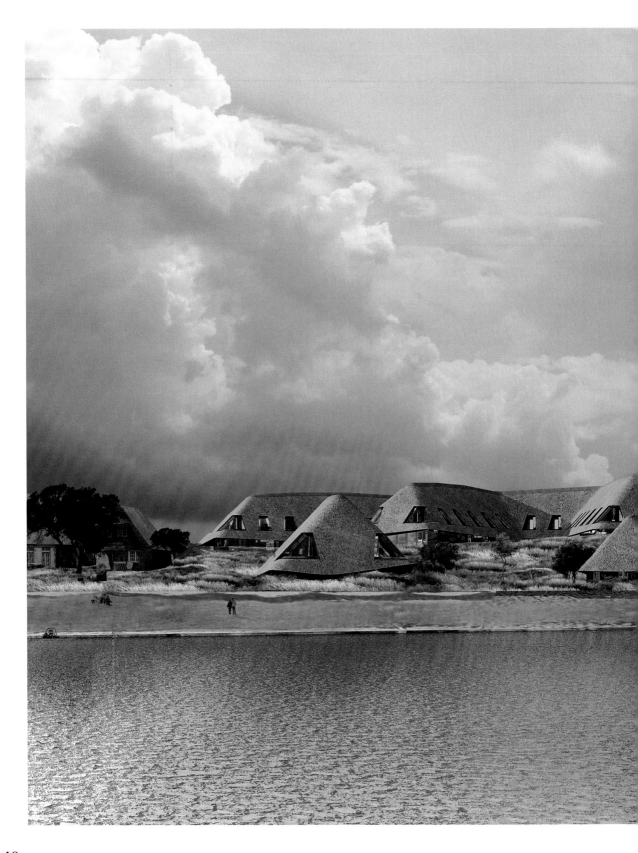

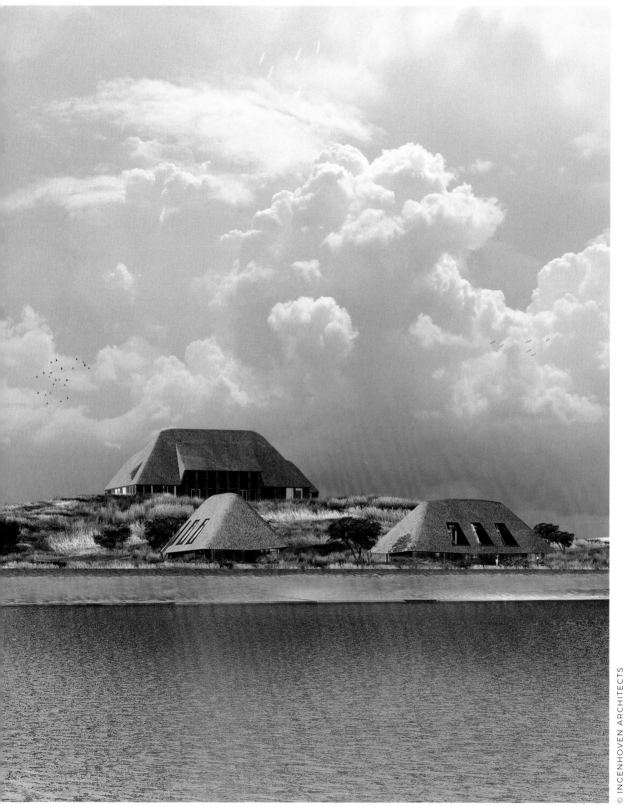

© INGENHOVEN ARCHITECTS

The island's pure air, the walks in nature and the seawater pools all contribute to the healing benefits of the Lansherhof wellness treatments. These range from a minimum of seven days to three weeks and teach participants to centre themselves, reconnect with their body and gain better control over their mind.

The list of daily workshops on offer is extensive but not compulsory: meditation, singing bowls, Qigong, yoga, Pilates and more. Various check-ups (including blood, allergy, hormone and gastrointestinal tests) allow guests to benefit from a tailor-made wellness experience. With the range of aesthetic medicine available, guests can benefit from treatments aimed at improving their wellbeing both inside and out: from tooth whitening to mesotherapy, cryolipolysis (cold slimming), ultrasound and more.

As regards diet, there are six variations, from the strictest cure to the 'active' diet: the lower the number, the more drastic the diet (0 = fasting). A diet around 2–3 has vegetables and proteins (local lake fish), yoghurt (ewe's milk) with linseed oil and buckwheat toast, lentil noodles ... Exceptionally a 'therapeutic' coffee may even be allowed.

The wellness concept at Lanserhof Sylt is light, lively, excellent and borrowed from the Vivamayr diet, which advocates eating slowly, chewing each bite up to 30 times and eating meals at fixed times: breakfast at 7am, lunch at midday and supper at 5pm, in line with the body's biological rhythm.

After an infusion of local herbs, it's early to bed because rest is the key to losing weight and getting back into shape.

© ALEXANDER HAIDEN

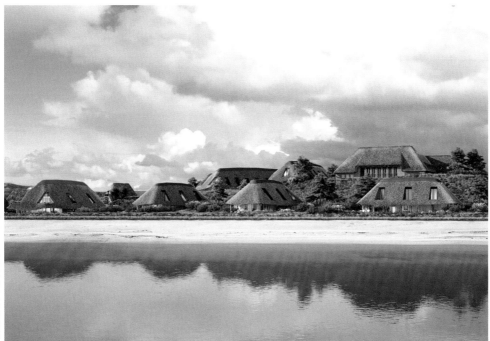

© INGENHOVEN ARCHITECTS

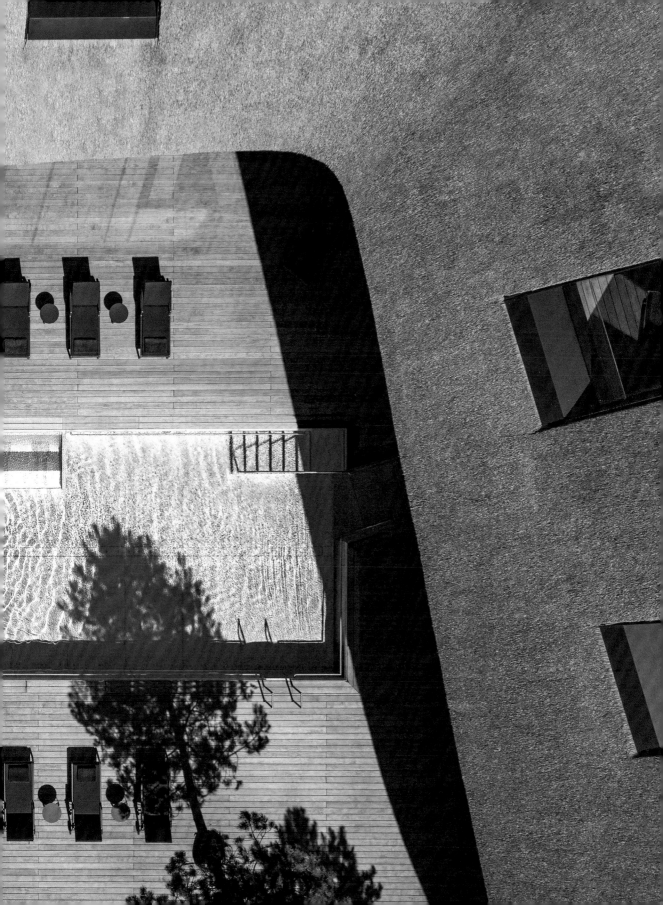

TO THE ROOTS
OF DETOX

Although they may not necessarily mention him directly, most detox centres base their medical practices on those that Dr Franz Xaver Mayr developed in the twentieth century when he recognised that the intestine was the root cause of many pathologies. This Austrian physician developed a method based on resting, purification and learning to chew slowly. His method has yielded surprising results that are more relevant than ever in this age of high-sugar beverages and processed foods.

European, American and even Indian guests travel every year to the prestigious, eponymous wellness centre located on Lake Wöthersee to follow Dr Mayr's very special diet.

VIVAMAYR

+43 4273 31117

vivamayr.com
office@vivamayr.com

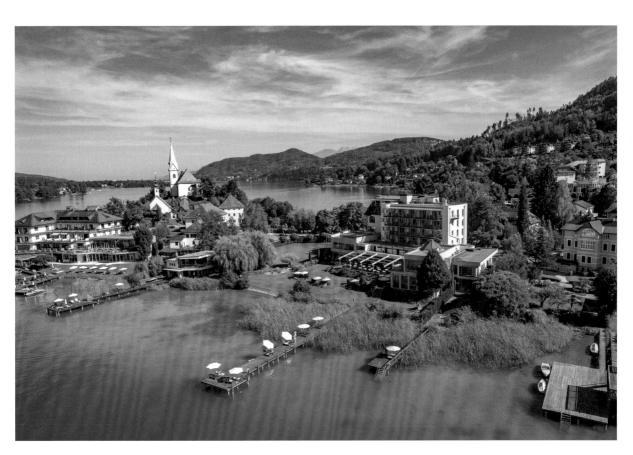

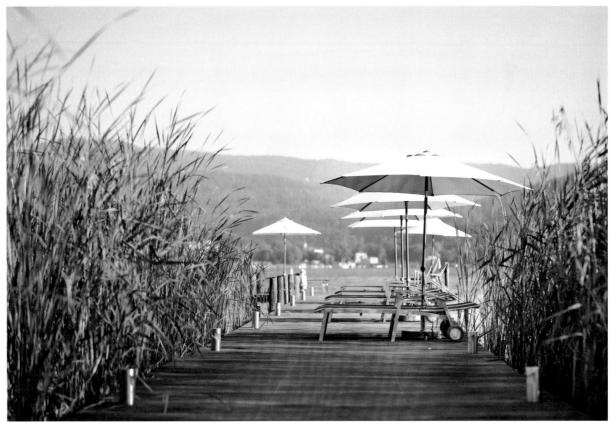

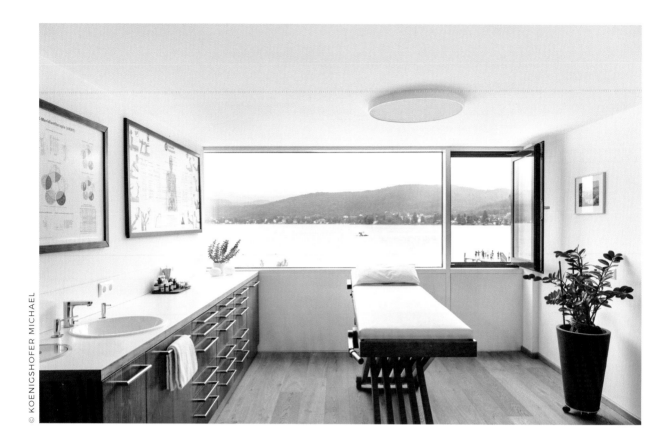

© KOENIGSHOFER MICHAEL

© KOENIGSHOFER MICHAEL

At Vivamayr, particularly careful consideration is given to what patients eat (no alcohol, no sugar or coffee, and a focus on alkaline foods such as vegetables, fruit, fish and white meat) but what's most important is the way in which patients eat. This aspect determines their digestion and therefore their health.

First of all, patients are required to focus while they're eating (no distractions from screens or mobile phones at the table) and to chew for as long as possible (ideally … 40 times per bite!).

Another requirement involves not drinking during meals. Instead, patients are invited to drink an hour before and after a meal, and between 2 and 3 litres of water a day. They are served very light suppers, and their diets are enriched with cold-pressed oils (like flax oil and hemp oil, which are full of omegas 3, 6 and 9) and supplements (which are personalised based on blood and urine tests carried out at the start of the cure).

Chewing for longer, at least 40 times per mouthful, improves digestion and enhances the feeling of satiety.

Outside mealtimes, the centre offers a range of therapies to detoxify the body, including a daily footbath in an electrolysis machine, massages of all kinds, nasal reflex therapy (which takes around 20 minutes and aims to purify the sinuses by placing cotton wool soaked in essential oils in the nostrils) and kinesiology to determine certain food intolerances. The setting is quite rigid, with set procedures and timetables, which is ideal when trying to adopt healthy eating habits.

Long after their stay, Vivamayr guests say they all remember the chewing trainers, the hardened bread rolls to practise chewing, the mouth oil in the morning on an empty stomach to eliminate bad bacteria and toxins, the hot water bottle placed on the liver in the evening … and lights out at 10pm!

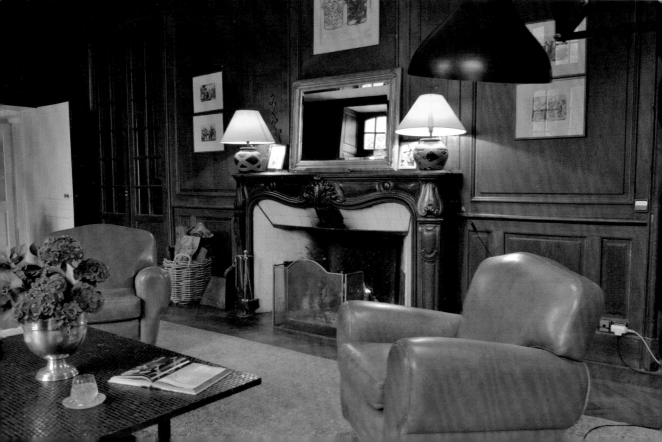

CHÂTEAU DU LAUNAY

BRITTANY, FRANCE

THE BEST PLACE IN FRANCE FOR A 'SOFT' DETOX

Journalists, actors and other wellness connoisseurs all recommend this place to their friends and it's easy to see why. Carole de Thoury Bogrand, the owner, immediately makes you feel at home. Every week, her château – located in the heart of the Gulf of Morbihan and built to golden ratio proportions – welcomes a dozen guests wanting to totally disconnect from it all.

This wellness centre is characterised by its hospitality, its luxurious yet friendly facilities and the magical natural surroundings (not only the property's grounds but also the nearby forests, which offer fantastic hiking opportunities).

Over the last few years, Château du Launay has established itself as the gentle alternative to radical fasting therapies. Here, everyone has their own broth, a juice (perhaps diluted) or even a vegan meal. The aim here is not to suffer but rather to experiment and to test our relationship with food, our personal time and our attitude to life in general.

There's nothing medical or procedural about these facilities but the team is extremely professional, from the chefs to the natu-ropaths and hydrotherapists. The large wooden kitchen table

CHÂTEAU DU LAUNAY

+33 2 97 39 46 32

chateaudulaunay.fr
info@chateaudulaunay.fr

and the incredible library (which would make you want to stay for weeks) provide a friendly and inviting setting that almost always leads to a sense of camaraderie among the guests.

In your room you'll find a small wellness kit, including a tongue scraper and a neti pot (to clean your sinuses), an exfoliating glove and a notebook to write down your feelings throughout the experience, if you feel like it. Each day starts with a wake-up call to the sound of a gong (7.45am), followed by a yoga class (8.15am), three hours of hiking, free access to various treatments: sauna, hammam, the Bol d'Air Jacquier natural oxygenation method and apitherapy treatments, where you can observe the bees as they bustle about from behind a glass window. There are also à la carte treatments: massage, colonic hydrotherapy, energy sessions with the 'local magician' Bénédicte and equine therapy, a speciality of the house, which has wonderful stables.

It takes up to 21 days for the brain to get used to something and it functions even better when we eat less!

In the evenings, lectures on specific topics (naturopathy, meditation, skin ageing, etc.) lead to lengthy discussions by the fireplace. Gently, we allow our bodies (which are often fed too much, too often and too fast) to rest. A stay at Château du Launay is an opportunity to learn to let go, to listen and reconnect with our body (you'll even learn to talk to it!).

After a few days, without realising it, you won't even think of reaching for your phone. And when it rains (which often happens!), it's another excuse to pick up a book, write or just do nothing. Body, skin, emotions and mind: the transformation is spectacular.

But the staff insist that the challenge lies in keeping up the good eating habits when we resume our normal diets – and that's fair enough.

This little unspoilt spot in Brittany is undoubtedly the best place in France to start a wellness journey.

© BENJAMIN SELLIER

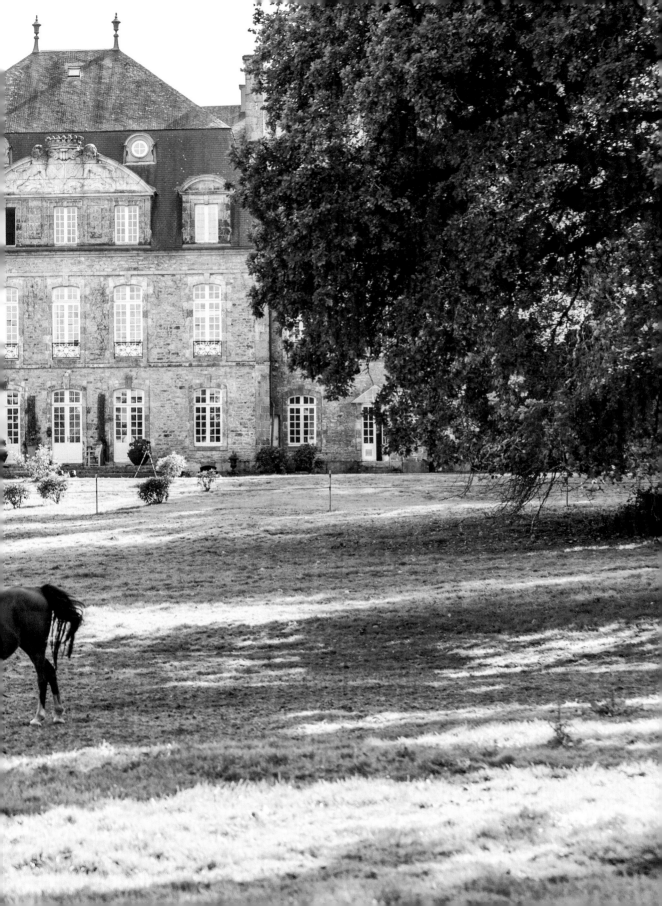

PERSONAL
REJUVENATION

For 20 years, reflexologist Gwenn Libouban tended to patients at her Paris practice and at prestigious hotels. She is renowned for her magic touch and exceptional intuition: in just one hour she can pinpoint tensions, release long-standing anxieties and recharge tired batteries.

According to reflexology, certain sensitive points on the feet are connected to the internal organs and bodily functions but also to emotions and their manifestations.

**L'ARBRE
QUI MARCHE**

larbrequimarche.fr

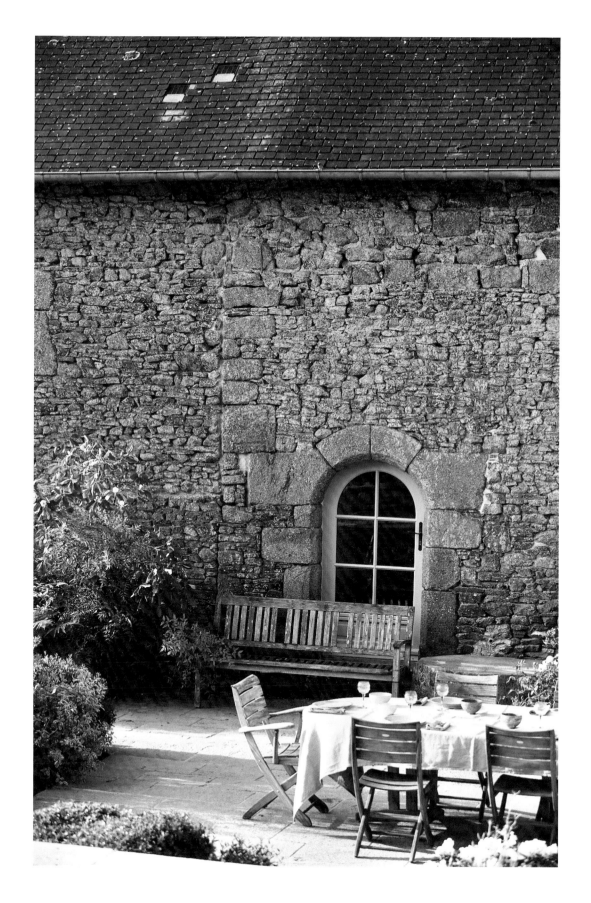

Now based in Brittany, Gwen gives her treatments at La Ferme du Vent, an establishment owned by the Roellinger family. She has just opened her own space dedicated to her retreats at La Villate, a hamlet in beautiful countryside with centuries-old oak trees (between Rennes and Saint-Malo).

L'Arbre qui Marche ('The Walking Tree') is a retreat centre that Gwenn designed together with dancer, acupuncturist and philosophy graduate Paolo Malvarosa. It provides an intimate and private experience, very different from what is available elsewhere.

Four hands, three days, three pillars (reflexology, dance and yoga), gongs and lots of space for introspection: this is the essence of their pretty farmhouse. Made of natural materials that breathe and let you breathe (the walls were renovated with raw earth, the paint is made of natural pigments, the mattresses are stuffed with Breton sheep's wool ...), the farmhouse is surrounded by a walking garden. Just as in Japan, the walking garden is designed as a reflexology path to be explored barefoot and with complete peace of mind, in order to stimulate the soles of the feet.

It's a place of sharing where you can recharge your batteries but also take part in a range of courses.

In addition to seasonal programmes designed to respond to the body's needs throughout the year, individual and tailor made retreats are also available. Gwenn and Paolo serve Ayurvedic-inspired organic cuisine (the herbs, fruit, spices and remedies are all sourced from the garden), 'nourishments' for the body and mind that focus on living well and, as they put it, a reset of all the senses: sight, smell, touch and taste.

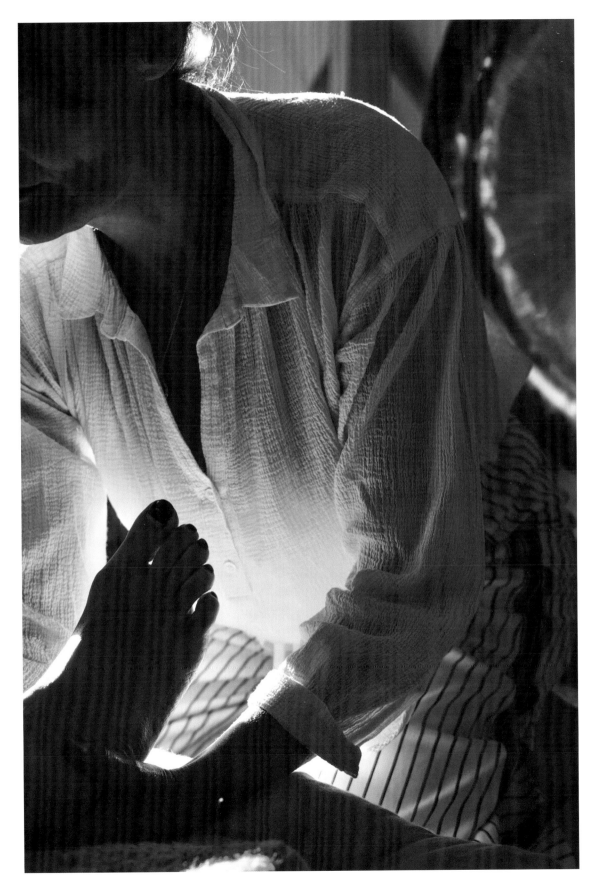

LES TILLEULS ÉTRETAT

NORMANDY, FRANCE

PERSONAL DEVELOPMENT ON THE CLIFFS

The cliffs of Étretat may be one of Europe's most impressive sites but setting up a holistic centre there was a risky gamble. And yet, this is exactly what Camille Gersdorff did. The globetrotter, personal development enthusiast and daughter of a Belgian Michelin-starred chef opened her charming guest house in a haven of greenery.

The Second Empire mansion has just five cosy rooms, antique furniture and flowery curtains, a garden opening onto a long sunny terrace and a driveway lined with lime trees. It feels like a genuine family home with a warm, friendly atmosphere.

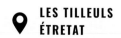

LES TILLEULS ÉTRETAT

+33 2 35 27 76 76

lestilleulsetretat.com
info@lestilleulsetretat.com

© FRENCHIE CRISTOGATIN

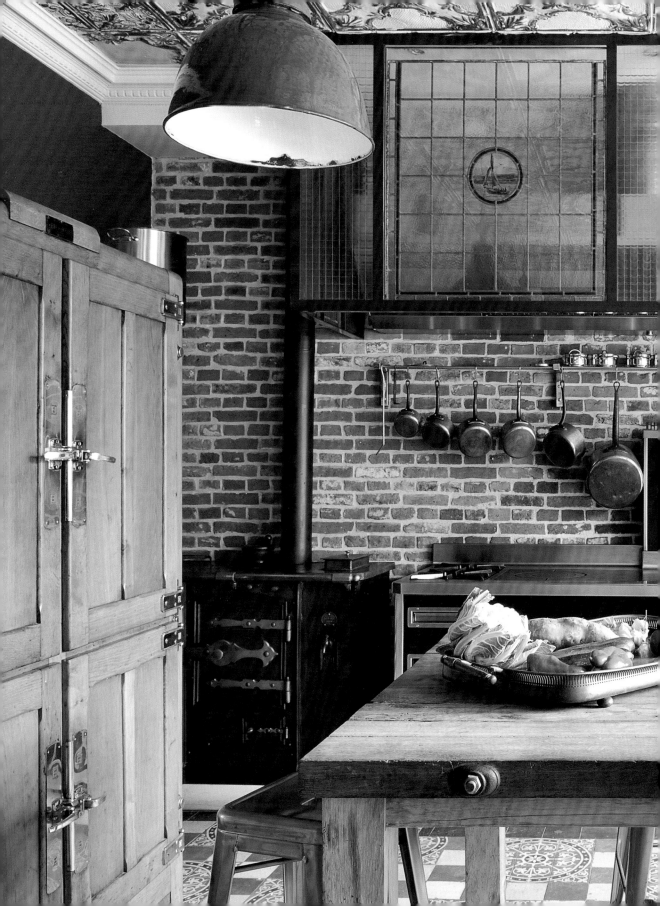

© FRENCHIE CRISTOGATIN

© JÖRG BRAUKMANN

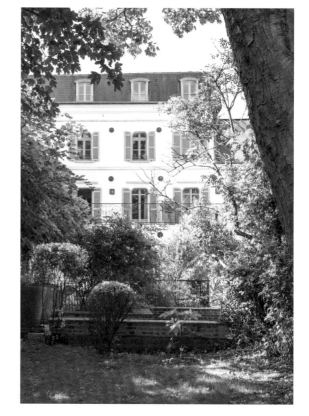

But that's where Monet, Delacroix, Maupassant and French classicism end. Camille regularly organises advanced yoga, meditation and Pilates retreats here (around 20 a year). As she wants to promote a holistic approach based on each guest's needs and life stage, she has learned something about every practice. As a result, Les Tilleuls is not afraid to go against the rules, offering stays that blend esoteric practices such as an introduction to tarot, gong playing, Kundalini and the Four Toltec Agreements. Retreats are designed to help guests better understand and integrate Don Miguel Ruiz's famous book, *The Four Agreements*, into their daily lives.

'Be impeccable with your word', 'Do not take anything personally', 'Do not make assumptions' and 'Always do your best': the Four Agreements are a philosophy and a way of life.

For the rest of the day, guests can occupy themselves with the cosy library, the steam room and the home cinema or laze on the nearby beach.

This trendy, welcoming retreat attracts fans of personal development as well as lovers of charming resorts in search of unusual experiences.

If you go there, or if you're in the region, don't forget to visit the nearby Étretat Gardens. Perched on top of the cliffs, just below the church of Notre-Dame-de-la-Garde, this avant-garde garden was brought back to life by landscape designer Alexandre Grivko. Blending art, technology and the power of nature, its large trimmed hedges echo the Normandy land-scapes and are conducive to meditation.

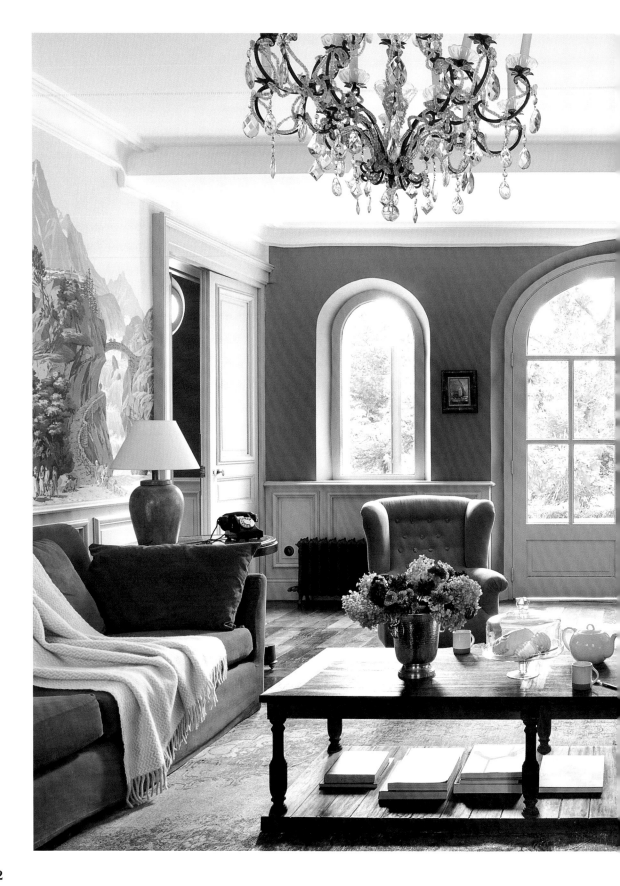

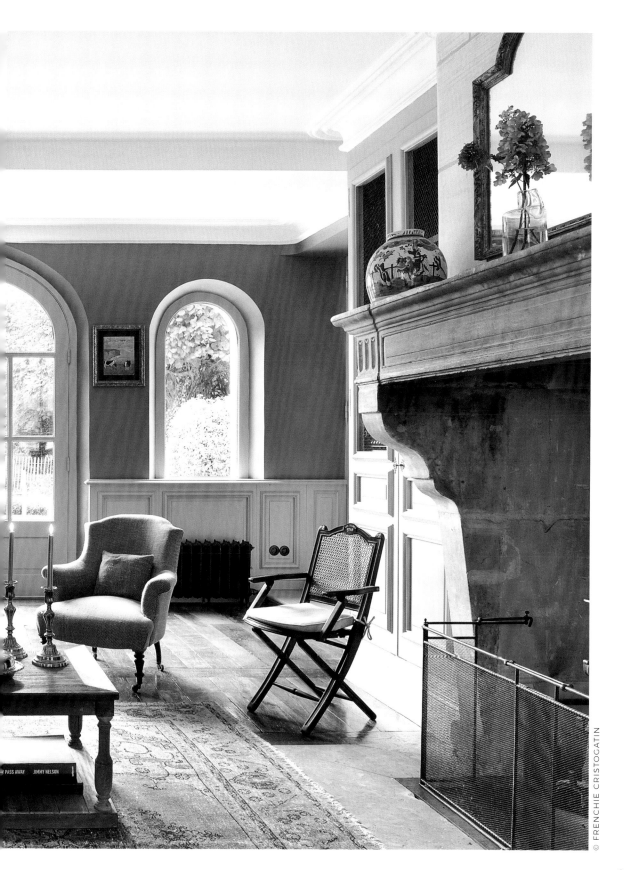

© FRENCHIE CRISTOGATIN

© NICOLEON

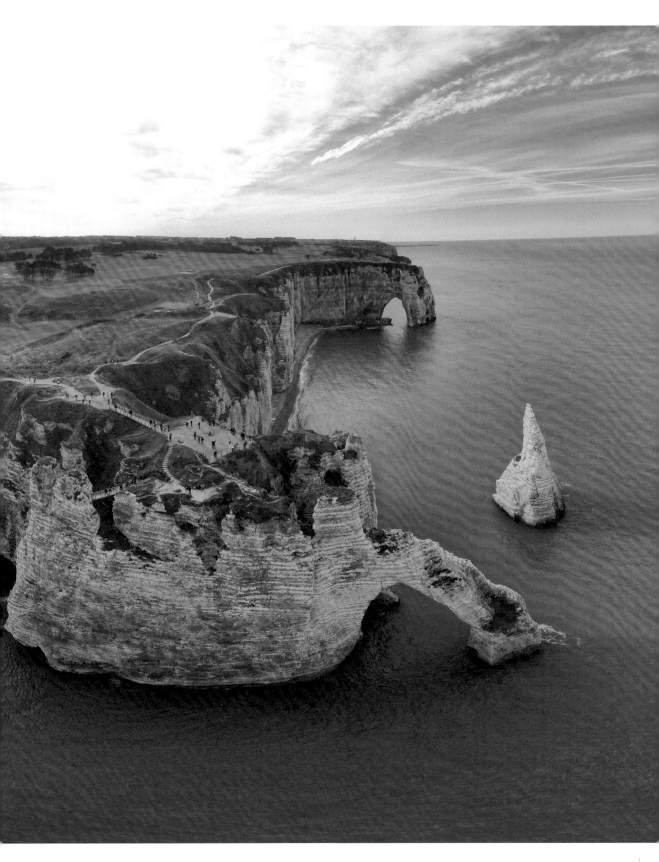

AN AYURVEDIC RETREAT 'MADE IN FRANCE'

An Ayurvedic retreat like in India but without leaving France? That's exactly what Tapovan offers. The retreat was created in the mid-1980s by France's pioneer of yoga, the charismatic Kiran Vyas, lecturer and author of the excellent book, *Yoga for the Eyes*.

Tapovan is an address in Paris (9 rue Gutenberg, in the 15th arrondissement) but most importantly it's a retreat in Sassetot-le-Mauconduit, Normandy (closest train station: Fécamp). Designed as an open university, Tapovan is the largest Ayurvedic centre in France and it remains a go-to reference.

 TAPOVAN

+33 2 35 29 20 21

tapovan.com
tapovan@tapovan.com

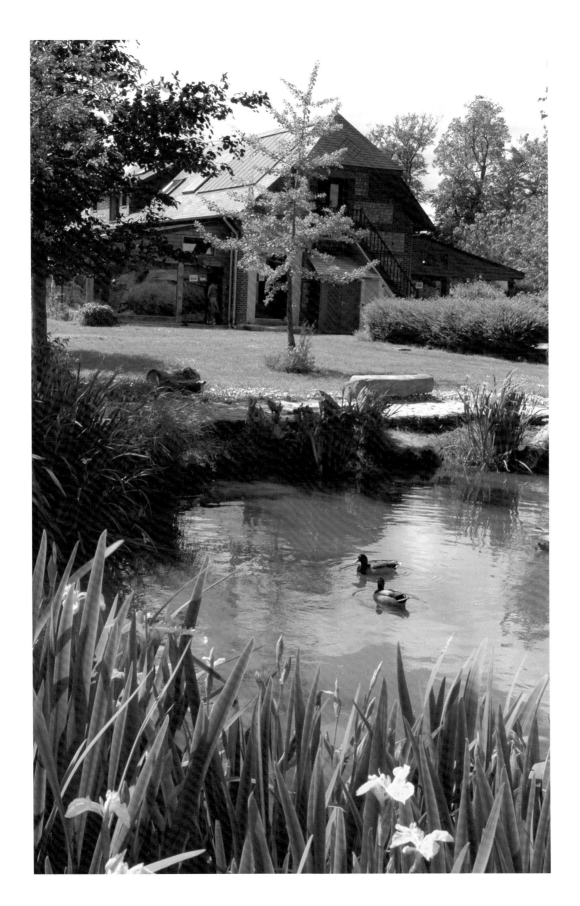

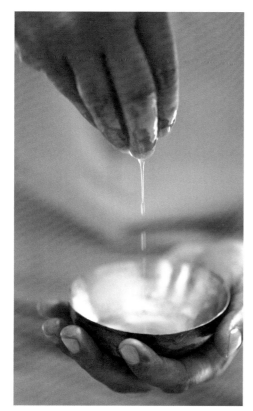

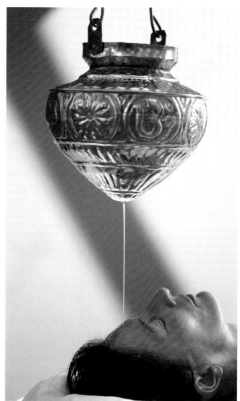

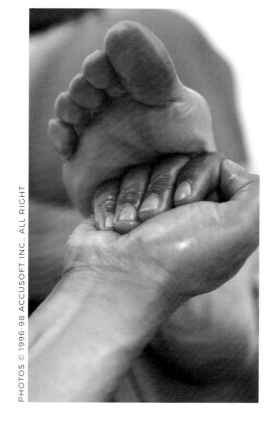

PHOTOS © 1996-98 ACCUSOFT INC., ALL RIGHT

The centre offers different types of treatments and massages as well as cooking classes for individuals and seminars for professionals. In the pure Ayurvedic tradition, the focus of the retreats is body care through nutrition (vegetarian meals correspond to each person's constitution, or dosha), yoga (soft Hatha), rituals (tongue scraping, etc.) and massage.

An Ayurvedic cure is much more than just a classic health and fitness programme. It brings in-depth revitalisation by seeking harmony with the five energies (air, water, earth, fire and ether) that make up the universe and our bodies and promotes a better understanding of ourselves. With its beautiful farmhouse and large estate, the Kiran Vyas centre is an ode to relaxation. Guests are regularly reminded that half their cure is on their plate and the other half in the garden!

Even if India's exotic landscapes are replaced by the Normandy countryside, and the peacocks and their trains are replaced by the cry of seagulls, a change of scenery is guaranteed. The Ayurvedic tradition is fully respected here.

The rooms are modest but pleasant. The treatments and the reception are in two different buildings, providing additional opportunities to stroll around the gardens and relax after each activity. It's good value, ultra-professional and very rejuvenating.

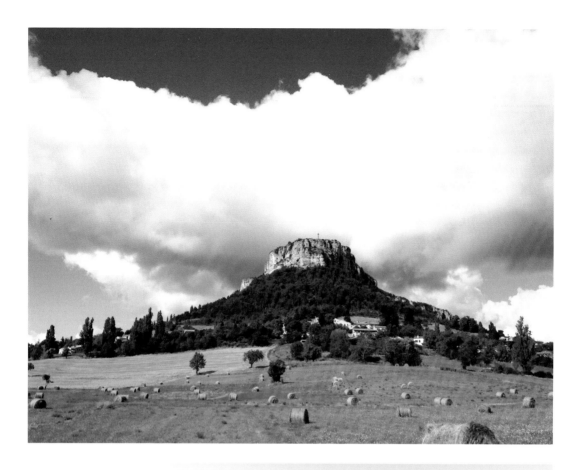

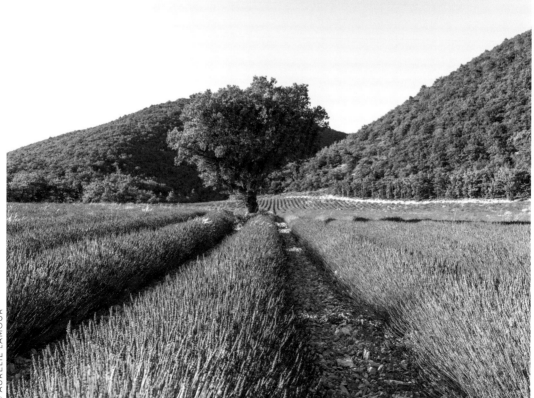

© AURÉLIE LAMOUR

TOTAL
DISCONNECTION

The French naturopath Thomas Uhl opened this fasting and detox centre in 2006. At the same time, he started a topic of conversation: he's convinced that by 2049, we'll be eating just two meals a day. In France there are no medical facilities that promote fasting, which is why the La Pensée Sauvage team recommends that you are in good health before embarking on its treatments. For those who can't or don't want to do a full fast, there are three other options available: fresh fruit and vegetable juices, an exclusive apple or cereal diet and a (light) plant-based diet.

 LA PENSÉE SAUVAGE

+33 4 75 44 55 58

lapenseesauvage.com
ecrire@lapenseesauvage.com

The centre regularly offers retreats outside its own facilities: in Ibiza, on the Portuguese island of Porto Santo and at the chic Domaine de Murtoli in Corsica. But the original setting at Plan-de-Baix in the Drôme region, at the foot of the Vercors mountains, is an integral part of the experience. Tucked away from it all, it offers panoramic views over the valley and minimalist rooms. Each session welcomes around 20 people, and guests are separated at mealtimes according to their 'menu' (those who eat are separated from the pure fasters).

After the slightly painful initial laxative, the group activities kick in – waking up at the crack of dawn for body awareness exercises, meditation and an invigorating daily hike (it would be impossible not to hike in the Vercors mountains!). Later in the day, time can be spent taking solitary walks, enjoying sauna and hammam sessions, massages, acupuncture, meditation or cooking workshops. In the evening, round-table discussions allow participants to reflect on and share their feelings. The testimonials are sometimes overwhelming.

A fasting cure involves resetting the body but also providing the right tools to maintain this new dynamic at home. These may include, for example: eating consciously, reviewing the basics of nutrition, following the right approach when it comes to mono diets or intermittent fasting, or doing a sixteen-hour nighttime fast between the last meal and the first one the following morning, which helps give the digestive system a rest.

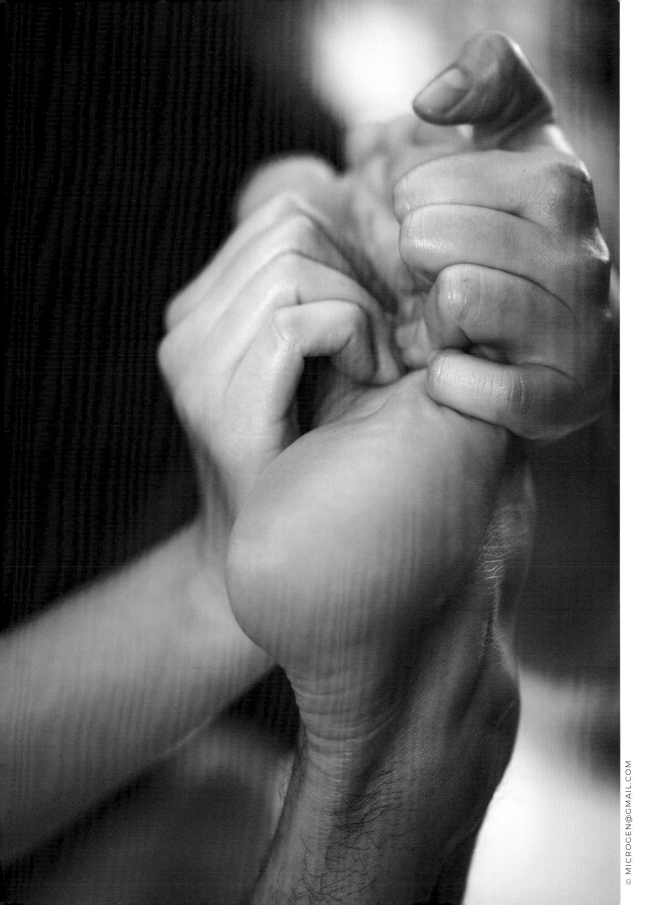

© MICROGEN@GMAIL.COM

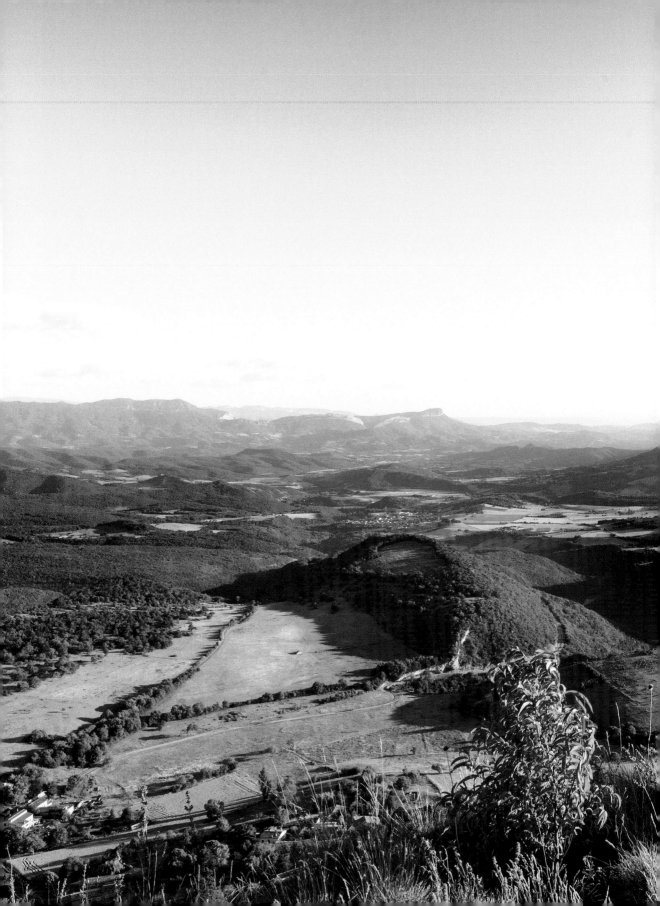

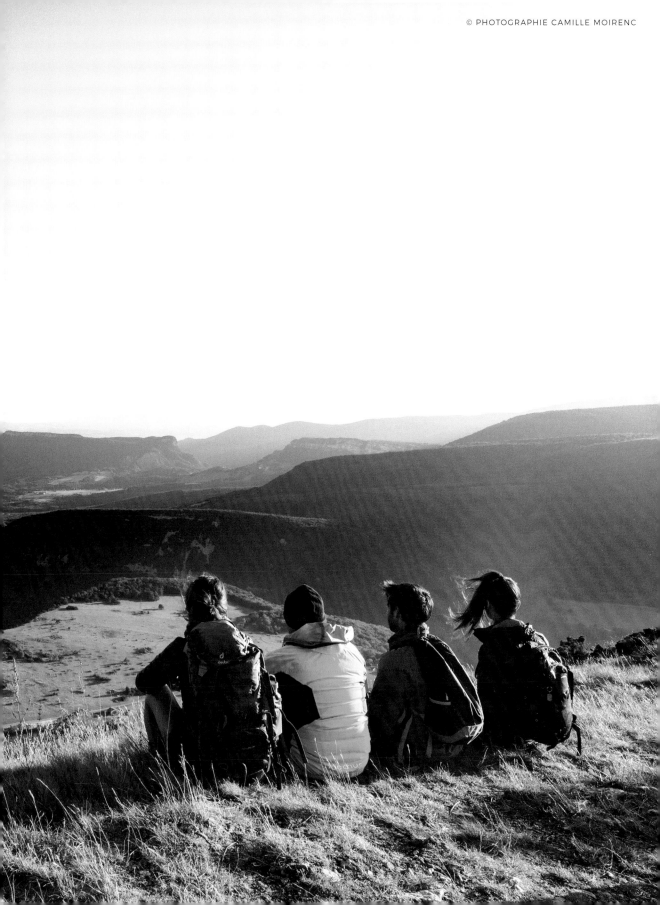

© PHOTOGRAPHIE CAMILLE MOIRENC

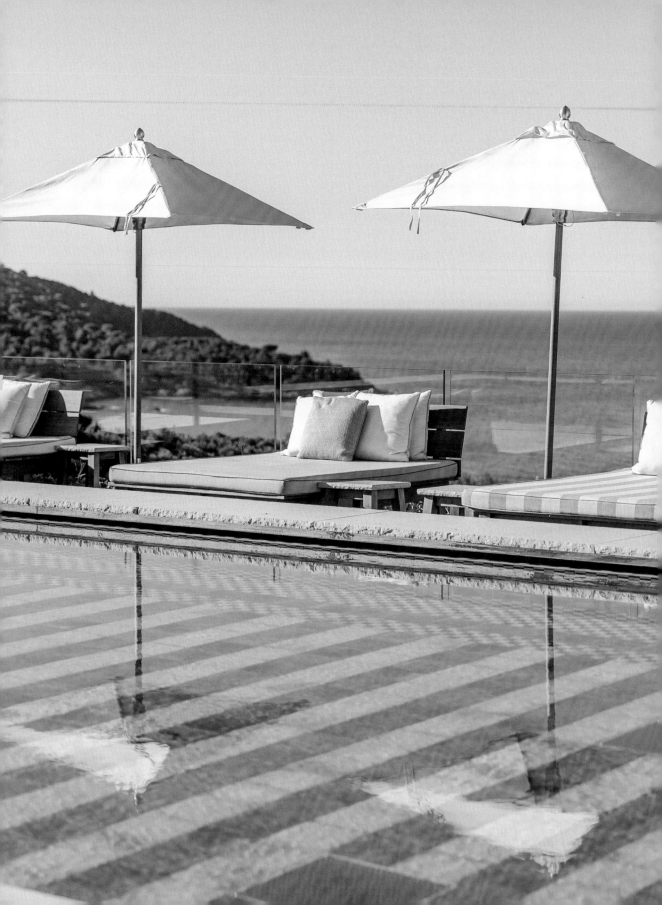

THE FRENCH RIVIERA'S BEST-KEPT WELLNESS SECRET

If you're looking for somewhere that combines fitness, relaxed luxury and French gastronomy, you've come to the right place. Located in the heart of the wilderness between Cavalaire-sur-Mer and Saint-Tropez, Lily of the Valley was born from a father and daughter's dream of creating their ideal hotel. Since opening, it regularly ranks among the best hotels in France. Far from the hustle and bustle of the Riviera, perched on the heights of La Croix-Valmer and with breathtaking views over the Mediterranean, this little paradise designed by Philippe Starck offers year-round (an exception in the region), targeted fitness programmes over four, seven, ten or fourteen days around four main themes: Better Aging, Weight Loss, Detox and Sport.

The welcoming, natural atmosphere of the rooms and restaurants, with their polished marble, solid wood, wicker, concrete, leather and ethnic fabrics, is an invitation to sit back and relax. But the Shape Club, a 2,000 m^2 space dedicated to body and mind, staffed by a team of experts (including nutritionists and sports coaches) and equipped with state-of-the-art technology, is where it all happens.

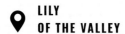

LILY OF THE VALLEY

+33 4 22 73 22 00

lilyofthevalley.com

Guests benefit from a full check-up, including an impedance diagnosis to assess their body composition (tissue, hydration and metabolism) as well as their flexibility and balance, free access to the high-tech gym, the hammam, sauna and snow shower, the semi-Olympic (heated) swimming pool and beauty treatments using Biologique Recherche products (undoubtedly one of the most effective brands on the market) and more state-of-the-art machines such as LED, HydraFacial and so on.

Group classes are included in the package and take place from morning to evening in the studio (TRX, yoga, stretching, boxing and more) or outside (cycling, walking, strolling along the coast).

Depending on your objectives and whether you're on a nutritional programme or not, you can follow the schedule and menus devised according to nutritionist Jacques Fricker's TGV method. (Meat, fish and vegetables, small quantities of fat, dairy products and fruit are all allowed but bread is not.) Losing weight (if necessary), (re)learning to eat healthily and keeping fit for the long term: this is the Lily of the Valley recipe that makes the establishment so popular that many guests return year after year to treat themselves to a health and fitness break.

The hotel regularly organises retreats in collaboration with well-known personalities from the world of sport and well-being, such as French free diver Guillaume Néry and Mathilde Lacombe, founder of AIME skincare.

Learning to live better and make the most of life doesn't have to exclude its pleasures. Lily of the Valley is one of the only establishments that manages to offer healthy options along-side a classic menu (the beach restaurant specialises in Italian cuisine). After a day of exercise, pleasure-seekers and/or guests accompanying friends who come for the wellness therapies can enjoy typical Provençal appetizers and a glass of rosé as they gaze at the sunset. There's no doubt about it: this is the French take on wellness.

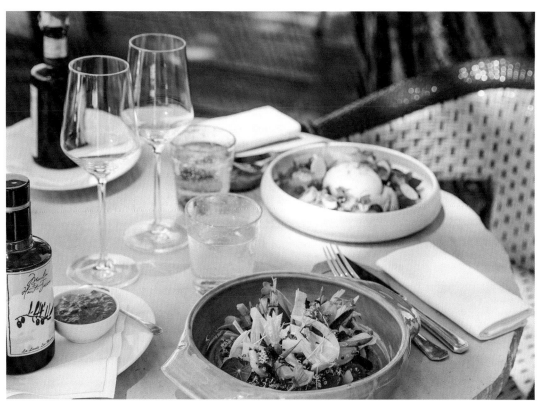

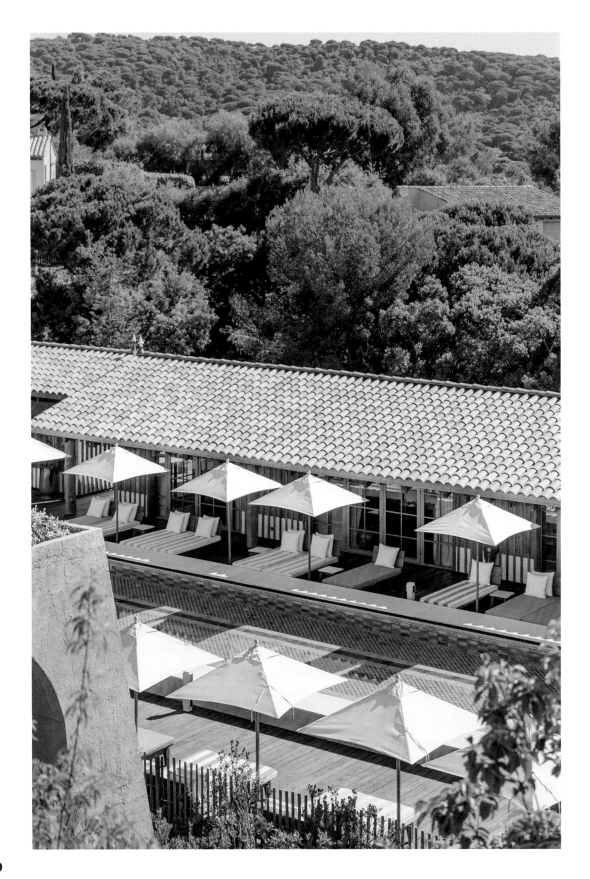

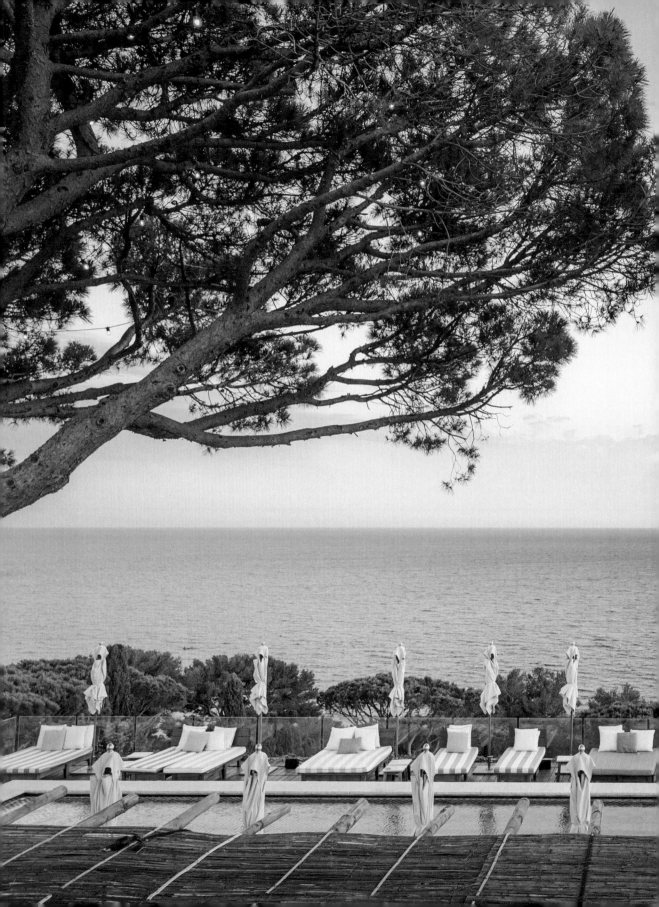

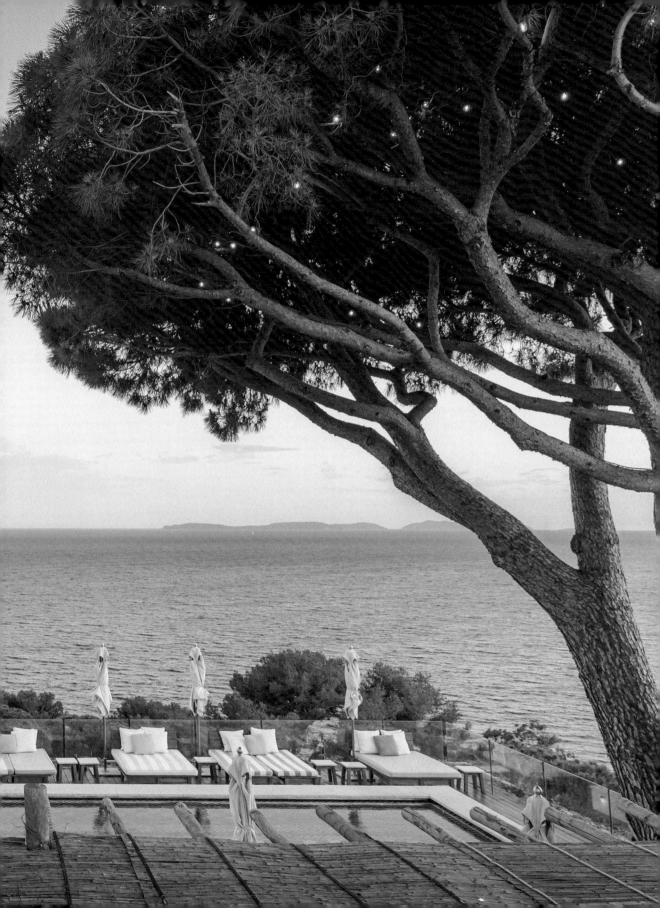

© RICARDO SANTOS

SUBLIME COMPORTA
PORTUGAL

A MINIMALIST
RETREAT

Uncluttered surroundings and elegant design are said to promote relaxation and stimulate creativity. 'Less is more' seems to be the motto of this retreat. The list of designers, journalists and stylists (it's a trendy destination) who say they've found inner peace by escaping the stressful hustle and bustle of the city and recharging their batteries at Sublime Comporta keeps growing.

 **SUBLIME
COMPORTA**

+351 269 449 376

sublimehotels.pt
info@sublimehotels.pt

Surrounded by a huge forest of pines and oaks (the Beach Club is ten minutes away), Sublime Comporta is one of the most beautiful hotels in Portugal. Architect José Alberto Charrua drew inspiration from traditional fishermen's huts to design the 34 independent rooms, some of which feature their own private pool.

Nature is an integral part of the wellness approach here and it provides most of the spa's resources: all treatments and rituals for body and face are created using organic essential and plant oils, local sea salt, plants, and rice from the garden.

Uncluttered settings and elegant design are said to promote relaxation and stimulate creativity.

The brief list of activities on offer varies according to the season – for a few days' stay, it's more than enough. It includes yoga, meditation, Pilates, HIIT and wellness programmes (relaxation, detox or tailor-made). For a first retreat in a very trendy environment, it's good value and accessible and offers a real opportunity to disconnect.

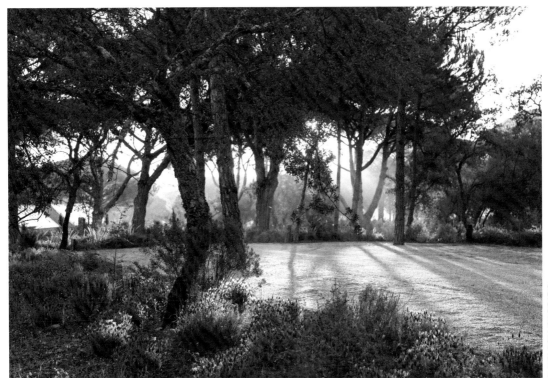

© NELSON GARRIDO

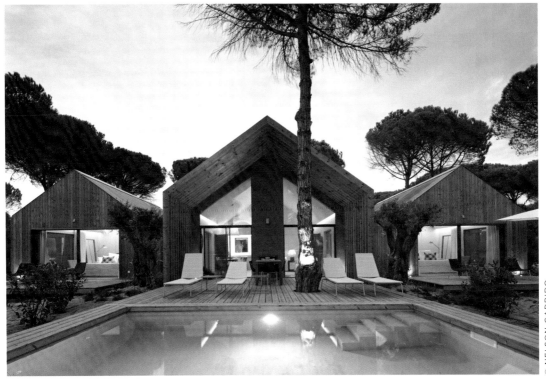

© NELSON GARRIDO

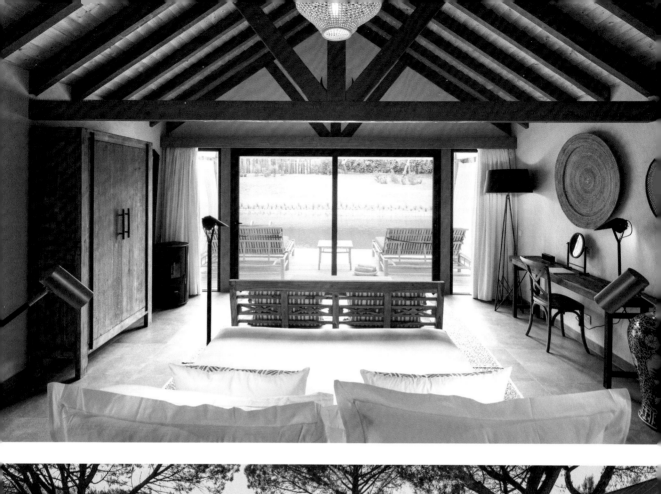
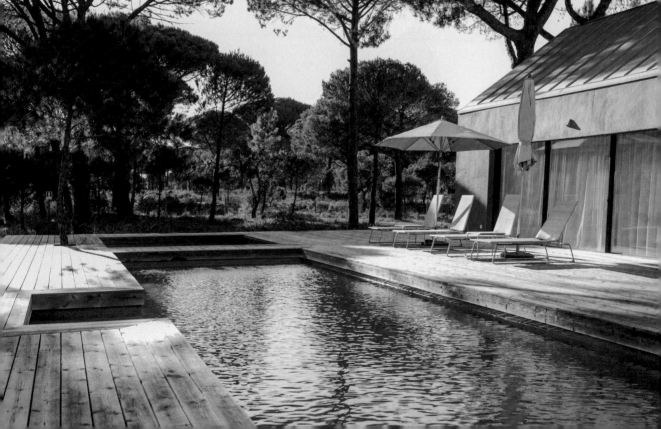

© RICARDO SANTOS

109

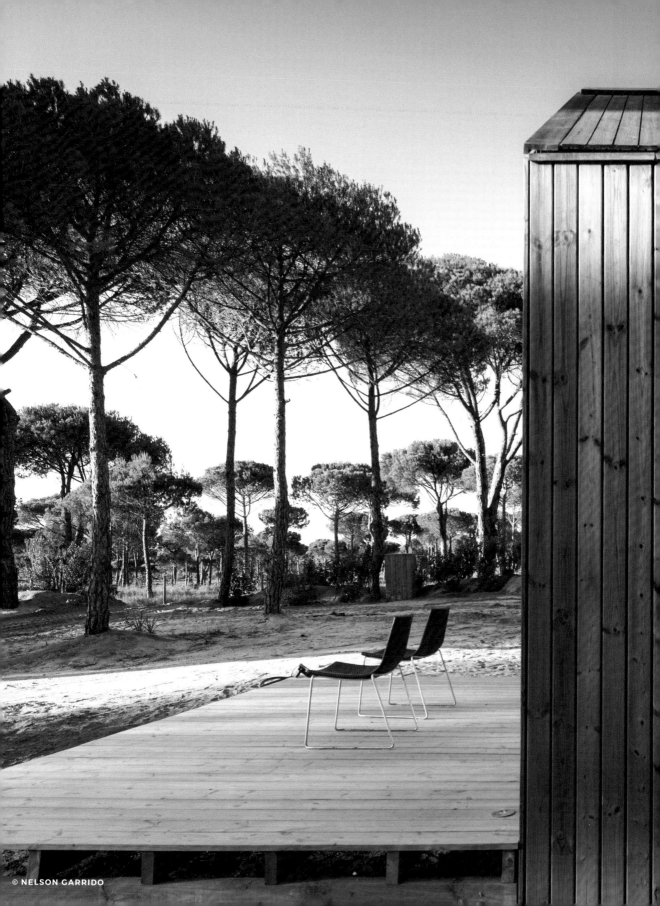

© NELSON GARRIDO

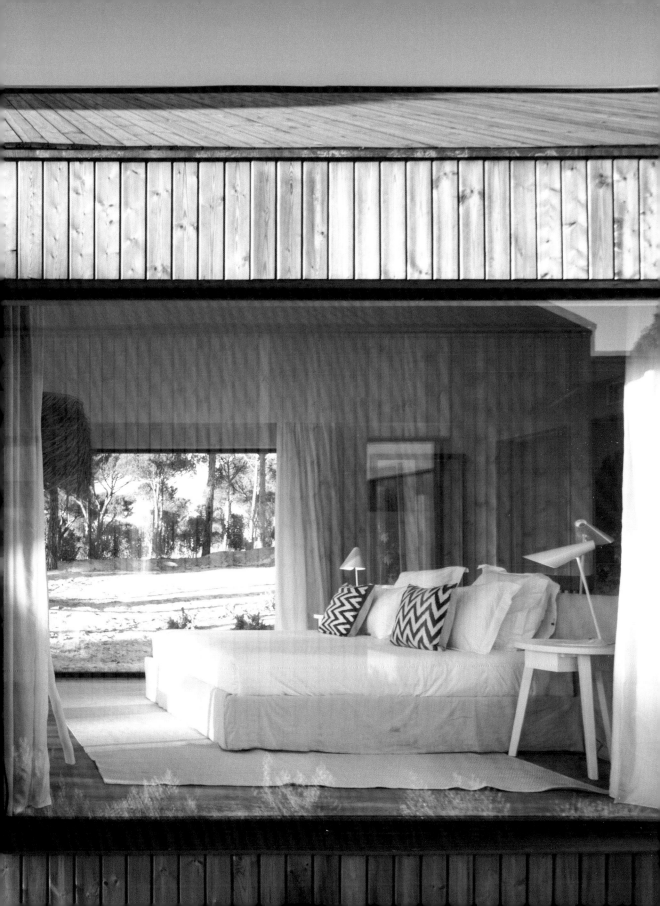

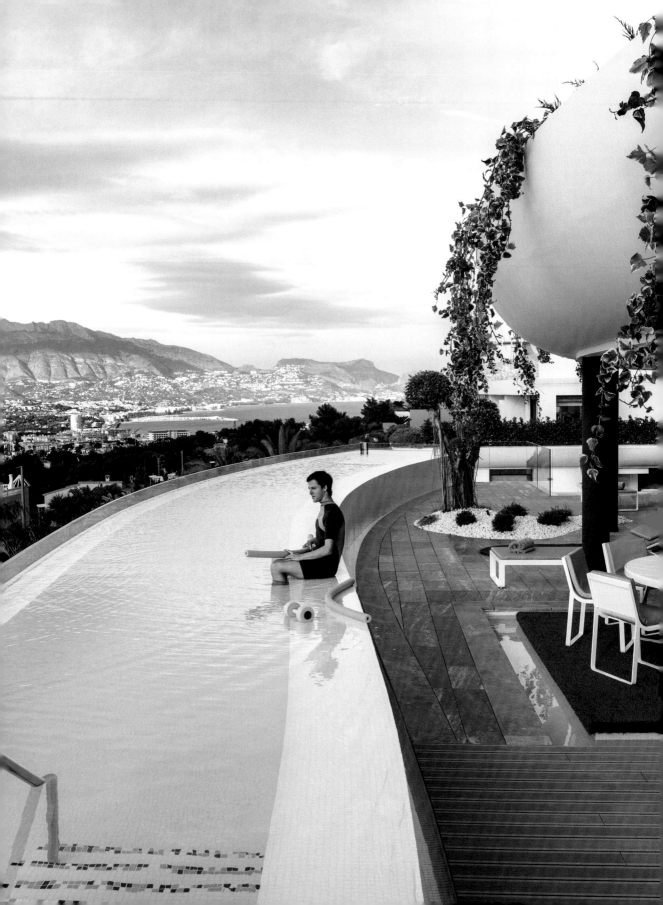

A MACROBIOTIC DIET AND HIGH-TECH HEALTH TREATMENTS ON THE COSTA BRAVA

Since its creation in 2009, this futuristic detox centre has always been buzzing. Often recognised as the best spa in the world, the Sha Wellness Clinic combines a privileged location (the sun shines even in the winter), ultra-specialised diagnostics and health treatments from the four corners of the globe.

This immaculate haven brings together the best of Asian medicine (think acupuncture and shiatsu) and Western science (genetic testing, oxidative stress tests, ozone therapy which consists of introducing ozone molecules into the blood, and other innovations). Most importantly, the centre has adapted over time to meet the new needs, or rather the new challenges. This is what gives it its edge.

For example, the spa is equipped with a cognitive development unit that aims to detect neurodegenerative diseases, improve memory and treat anxiety using a brain photobiomodulation system co-developed by NASA and Harvard University.

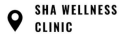 **SHA WELLNESS CLINIC**

+ 34 871 00 56 00

shawellnessclinic.com
info@shawellness.com

Another unit, dedicated to sexual well-being, includes a clinical evaluation with endocrine tests of each person's current situation as well as physical, emotional and psychological check-ups.

Additional 'focused packs' help address specific issues, including smoking and sleep recovery (nocturnal polygraph tests are used to identify sleep apnoea and insomnia patterns, followed by natural therapies such as acupuncture, phytotherapy and hypnosis).

The centre's newest treatment is a cold therapy procedure, like the Wim Hof method, which includes breathing exercises to relax, holotropic breathwork to release traumas, and ice baths. As well as being a physical challenge, the ice bath represents situations that create mental blocks.

But the clinic's most popular treatment is undoubtedly the Healthy Ageing therapy, designed to delay the effects of ageing, both internally and externally. This treatment includes a comprehensive medical check-up as well as an assessment of oxidative stress: together, they help determine the biological age (which can come as a surprise!) and any factors likely to have a negative impact on the quality of life. A combination of traditional treatments and modern therapies is then used to help the body recover in depth and slow down the ageing process.

Supermodels are regular guests at the centre ... However, there's nothing ostentatious about the Sha Wellness Clinic and everyone is made to feel welcome. The schedule of activities and treatments is conveniently shared every hour via iPad.

The centre's exclusively macrobiotic diet can be disconcerting at first but it quickly becomes one of the reasons that makes you want to come back.

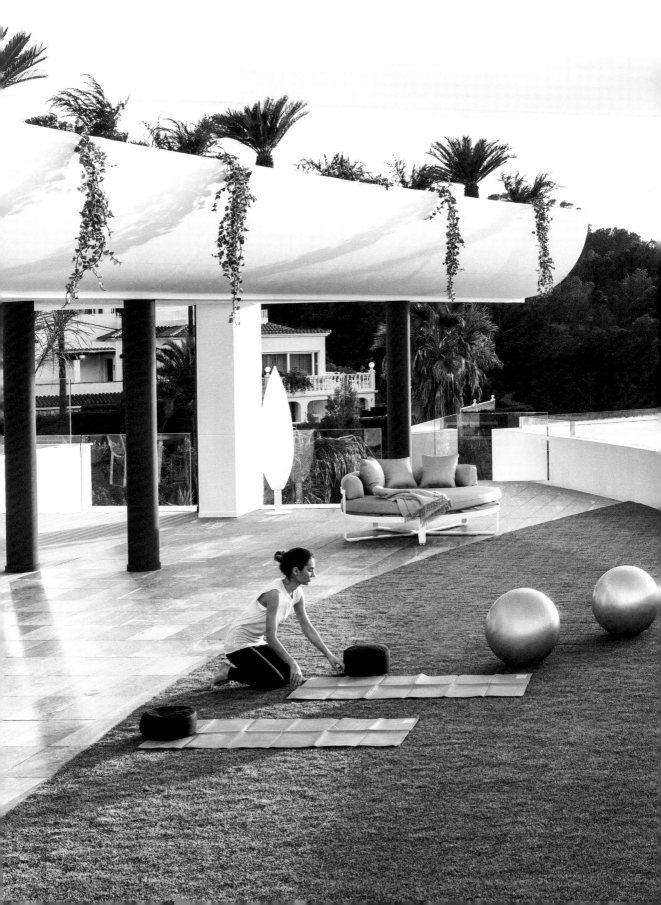

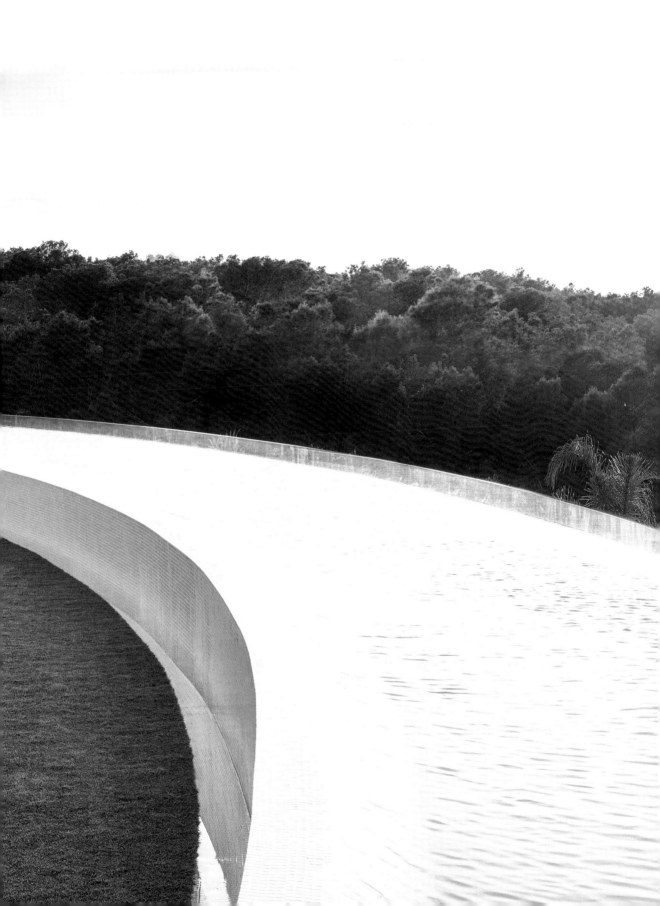

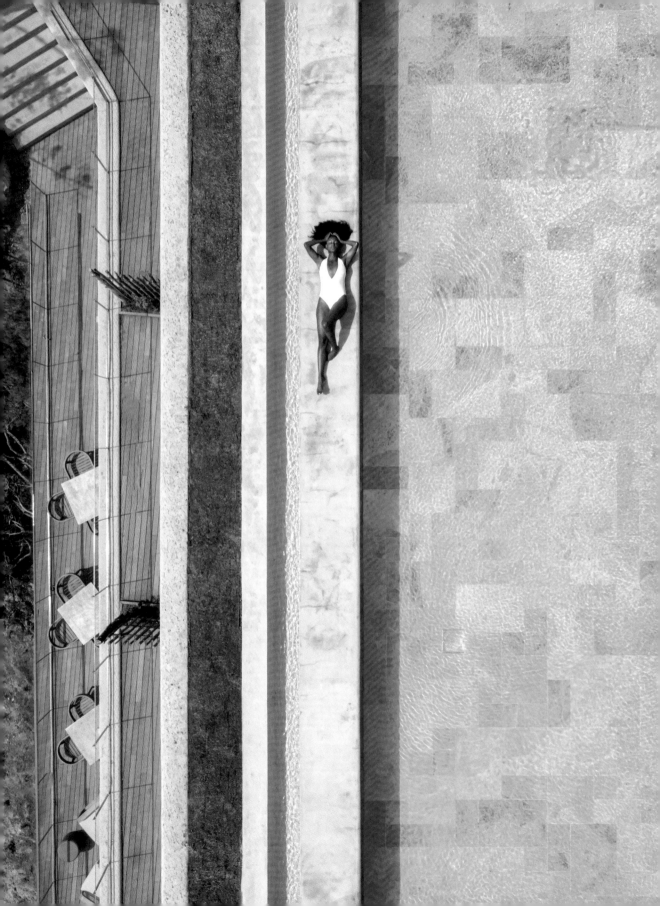

SIX SENSES

IBIZA, SPAIN

DISCOVER
THE BEST VERSION
OF YOURSELF

This is the hotel group that pioneered the world of wellness and it's located on the most 'hippie' island in the Balearics, if not the world.

Six Senses and Ibiza were made for each other. A long search for the ideal location led Six Senses to settle in the wildest corner of the island, in the bay of Cala Xarraca on the northern tip, where it's been enjoying a phenomenal success since opening at the end of 2021.

With its waterfront location and breathtaking views of the cobalt sea on one side and the pine forest on the other, the atmosphere here is festive, elegant and cool (even family-friendly). True to the spirit of the island, a strong feeling of community prevails at the hotel.

 SIX SENSES

+34 871 008 875 sixsenses.com

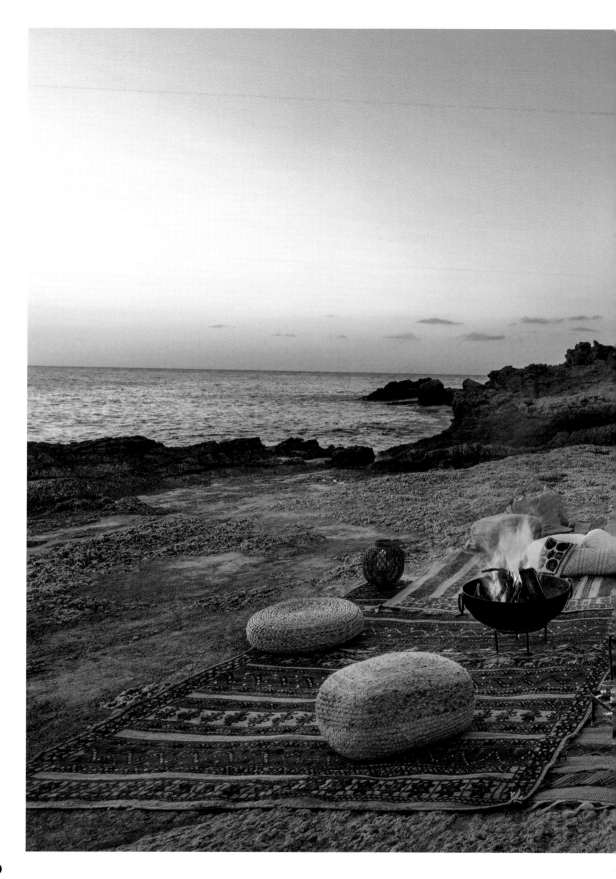

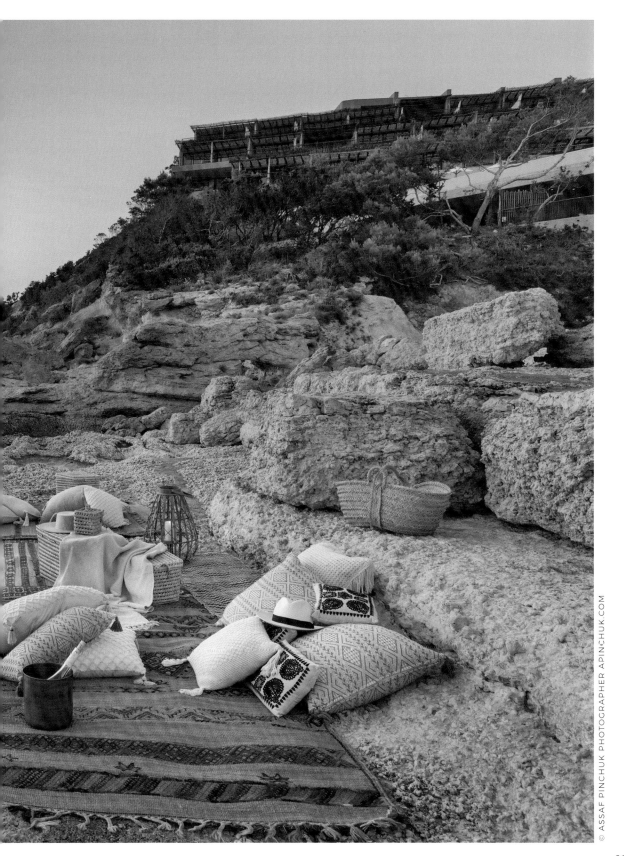

© ASSAF PINCHUK PHOTOGRAPHER APINCHUK.COM

The wellness programme is based on the three pillars that characterise Ibiza: community, spirituality and celebration. Just before check-in, all guests are invited to spend a few minutes meditating amid wisps of sage smoke. In addition to the traditional programmes offered by Six Senses (sleep, longevity, relaxation, beauty, detox ...) and the usual wellness treatments (cryotherapy, oxygen mask, infrared mat, LED light, compression boots ...), the spa has a selection of post-New Age disciplines: chakra meditation, underwater meditation, gong sound baths at sunset, facial yoga or yogic detox (practising a series of yoga postures while drinking salt water to cleanse the entire digestive system). These are all led by locals – after all, the island has no shortage of excellent health professionals.

The key words here are disconnecting, spirituality and returning to your inner self ... The hotel even arranges days dedicated to these themes – an ideal way to begin your stay.

A whole day can be dedicated to reflection, on your own and without access to the news (or the phone, of course) so that you learn how to connect with yourself using resources such as breathing, meditation, yoga and/or writing. As we know, every emotion generates either positive or negative energy and committing thoughts to paper can release some of this energy and promote mental clarity.

At Six Senses, even the younger guests have their own spa treatments (massages, reflexology, parent–child experiences). The food is organic, seasonal and local – some ingredients are sourced from the hotel's own farm and others from local farmers and producers.

One big plus: the hotel stays open all year round, which is rare on the island. Prices are lower from November to early March (when Ibiza is at its quietest).

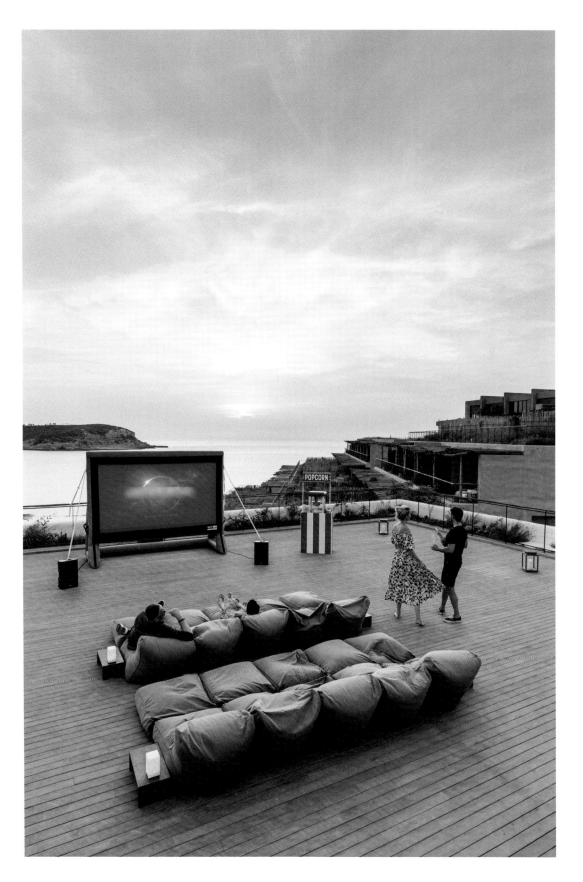

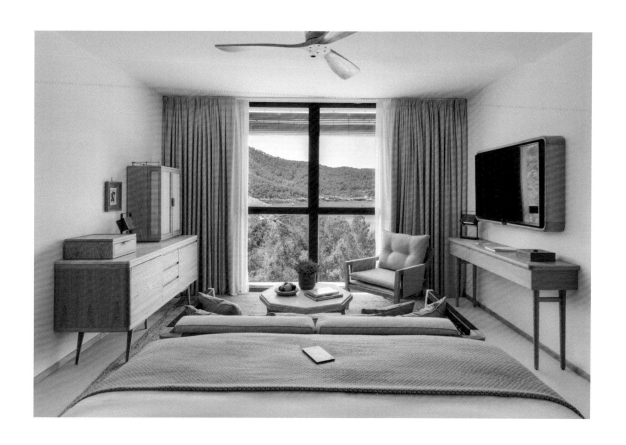

© ASSAF PINCHUK POTOGRAPHER APINCHUK.COM

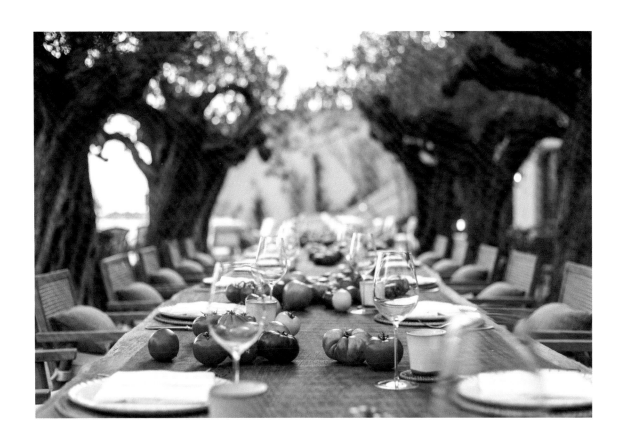

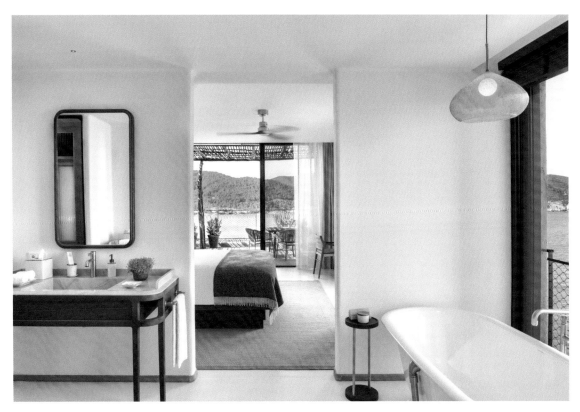

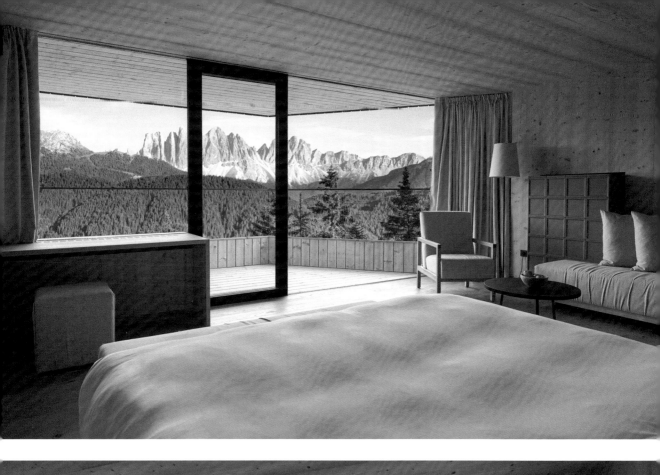

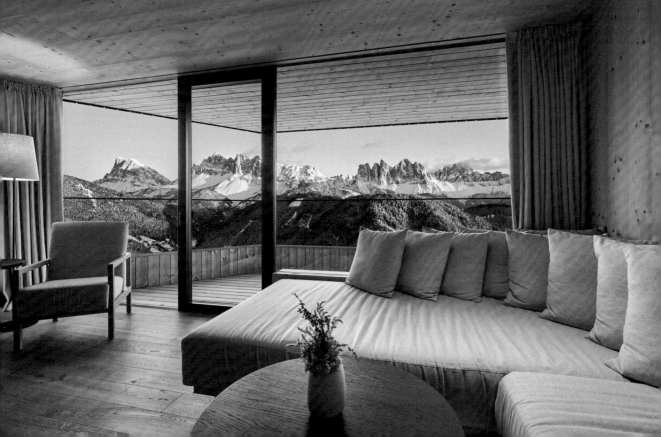

A GREEN DETOX
FACING THE DOLOMITES

At the beginning of the 20th century, the Austro-Hungarian Empire dreamed of developing a sanatorium in the heart of South Tyrol to benefit from the exceptional energy of the forest, the clear, revitalising waters of the Plose springs (flowing from the mountain glaciers), the wonderful fresh air and the above-average daily sunshine in the region.

In 2020 the Forestis relaxation complex opened in the heart of the Palmschoss mountains, at an altitude of over 1,800 metres, with spectacular views of the Dolomites. This temple of healing (constructed of untreated wood to release the precious, relaxing essential oils) is guided by minimalism, powered by renewable energy and entirely oriented towards the famous UNESCO World Heritage mountain range.

 FORESTIS

+39 0472 521 008
reception@forestis.it

forestis.it

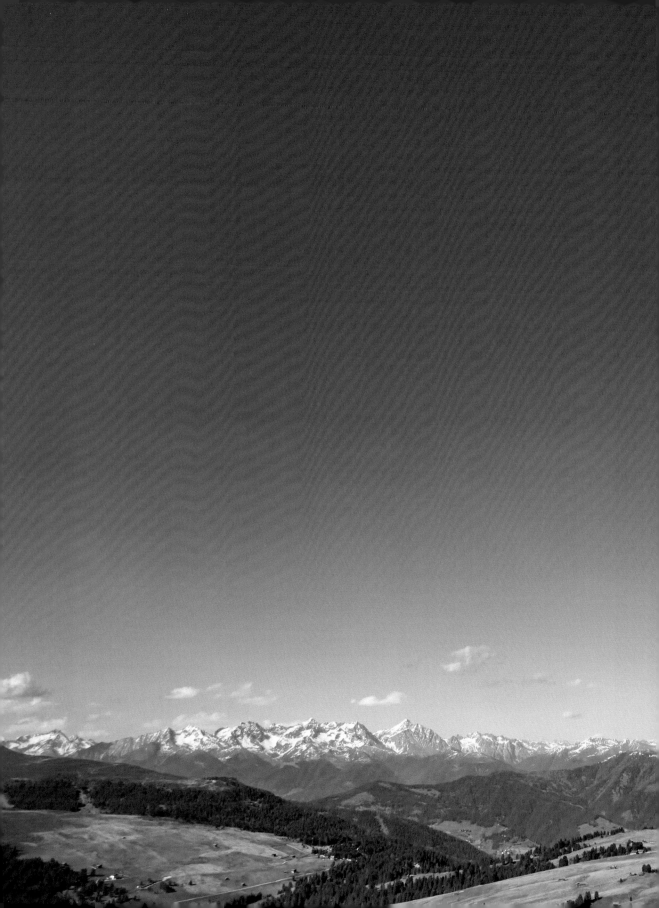

It's an ideal destination to soothe city folk exhausted by the hectic pace and stress of urban life.

In line with the notions of 'grounding' or 'earthing', Forestis is focused on natural energy and healing through trees (though we're not talking about hugging trees or healing in the strict sense of the term).

The science of sylvotherapy comes under the heading of naturopathy. Through being in contact with phytoncides (biologically active molecules released by trees to protect themselves from insects), our bodies respond by increasing the number and activity of a specific type of white blood cell: the natural killer cells (NK cells).

Numerous studies show that forest bathing boosts immunity, helps fight stress, improves the mood and reduces the risk of cardiovascular disease and diabetes.

The 2,000-m$^2$ spa has two pools (indoor and outdoor), saunas (Finnish, bio, textile, outdoor ...), a state-of-the-art gym (equipped with Technogym) and treatment rooms (featuring the four native essences of the surrounding area: mountain pine, spruce, larch and Swiss pine). There is also a room to practise Wyda, the astonishing yoga of the Celtic druids, which combines classical postures and Qigong (depending on the day, it can also be practised in the open air in the forest, along streams or by rocks). The hotel, which is fast becoming a standard wellness destination, also offers hiking, snowshoeing and skiing (45 km of ski in/ski out trails).

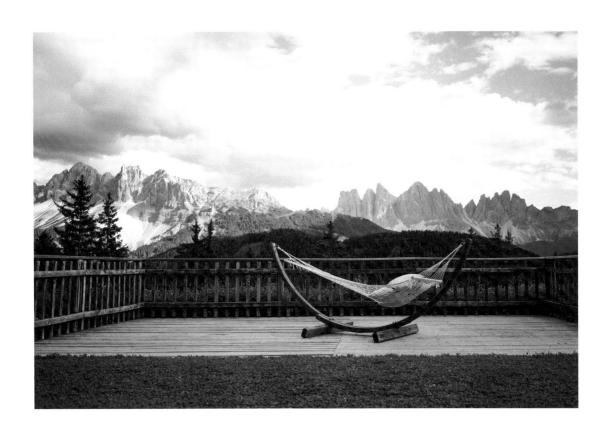

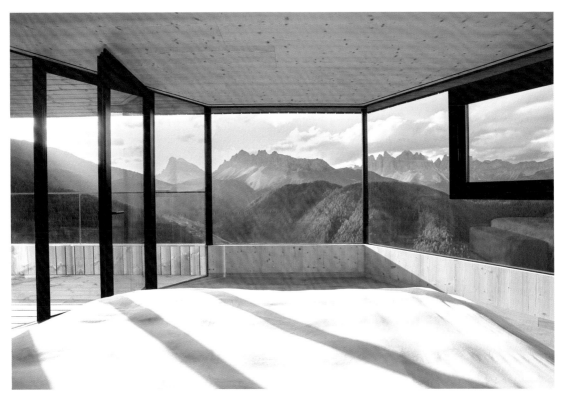

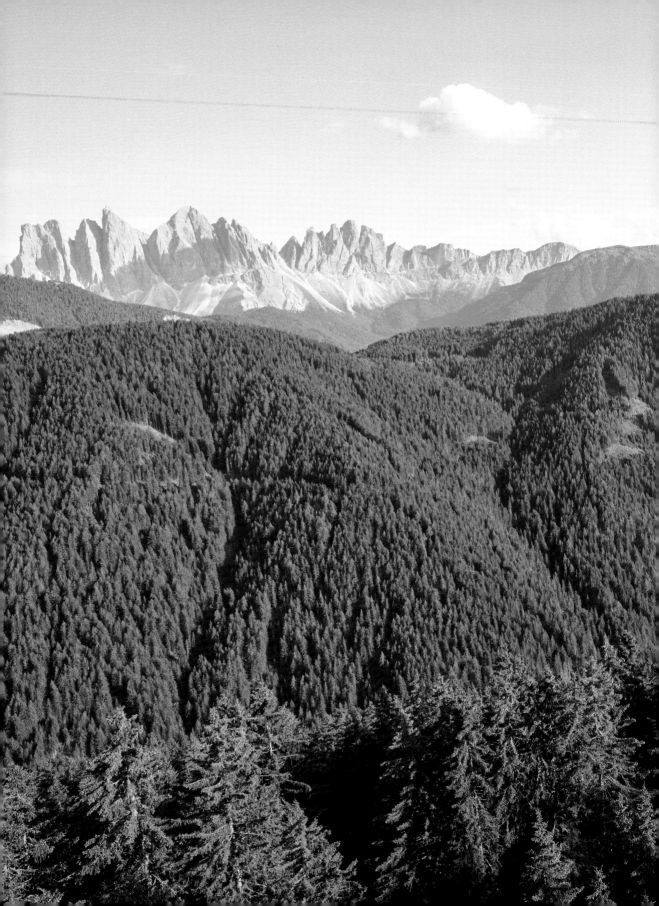

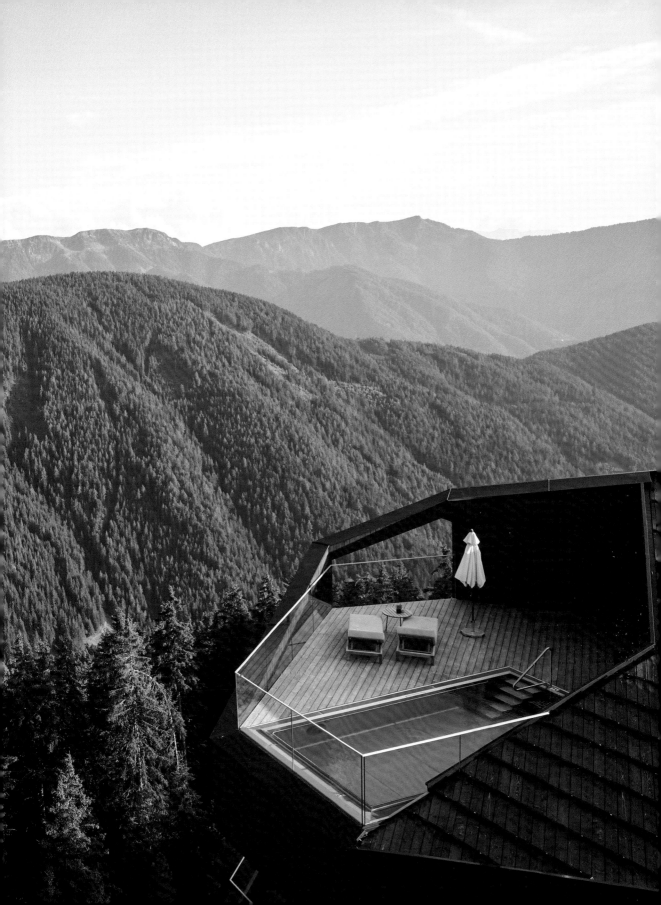

A FIVE-STAR
HEALTH CENTRE

Palace Merano has been popular with the biggest names in sport (especially football) and cinema, as well as top executives of the largest French listed companies, for the last fifteen years. Its secret lies in the quality of the treatments developed by Henri Chenot (since the doctor's death his name has been used as a brand by another establishment, not to be confused with Palace Merano!) and Dr Massimiliano Mayrhofer, and which combine sports coaching, dietetic nutrition, a medical spa and confidentiality.

The centre bears the name of a spa town located in a small valley in the region of Trentino–South Tyrol which became internationally famous when Chenot moved there to develop his detox method. Sure, a Mercedes with leather seats picks you up at Venice airport. There's no doubt that the setting is sumptuous and yes, we agree, the collection of cars in the hotel's parking lot is impressive. But these are just details.

 PALACE MERANO

+39 0473 271 000

palace.it
info@palace.it

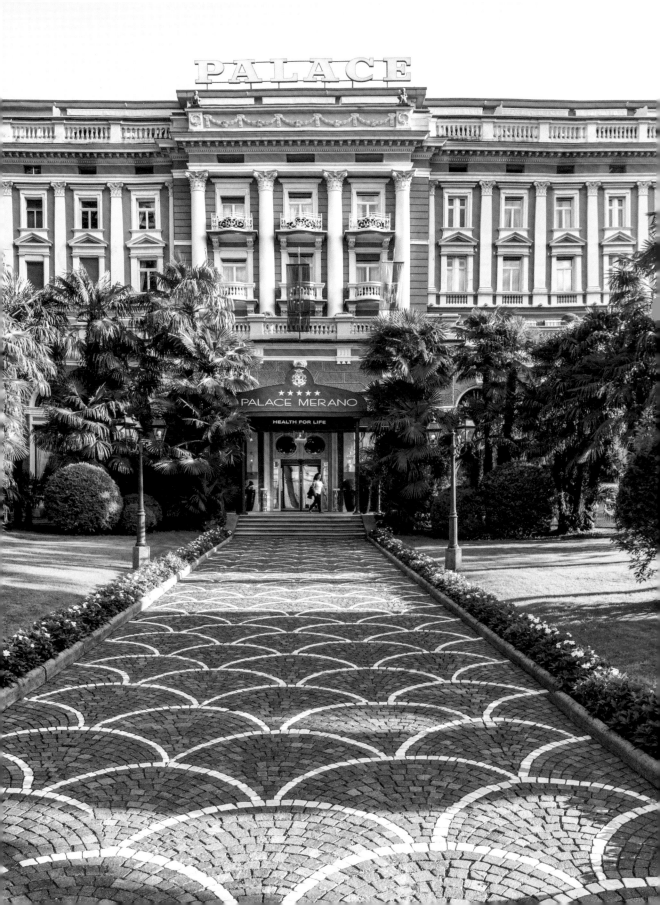

Regular customers say they leave transformed by the health programmes, which are regularly updated in line with scientific advances. The most popular treatment is the Revital Detox for Longevity, which consists of eliminating toxins, restoring energy and returning to a healthy weight.

It's important to remember that Palace Merano is also a clinic with its own in-house biological laboratory to analyse the results of an initial blood test (which checks for certain cancer markers) and a room equipped with a scanner.

After the purga (the term needs no explanation!) upon arrival, and in some cases a few hours or days of fasting, the whole team sets about its mission: passing on their knowledge of basic nutritional principles and encouraging clients to introduce them into everyday life once back home. On the menu, healthy, fresh foods rich in vitamins and antioxidants to regularly cleanse the deep tissues.

On the menu: healthy, fresh foods rich in vitamins and antioxidants to regularly cleanse the deep tissues.

Given that athletes often tend to leave home at a young age and rely on canteen food rather than macrobiotic restaurants, this may explain why they love staying at Palace Merano.

Palace Merano spa draws its inspiration from tried-and-tested thermal processes such as floatation booths, essential oil baths, seaweed wraps and more. The massages are based on traditional Chinese medicine practices and are performed both manually and with the help of electrodes to target a different organ each day.

Be warned: this spa is not for the lazy! Sports coaching sessions are an integral part of the programme and the hikes are intended to be physically demanding rather than meditative.

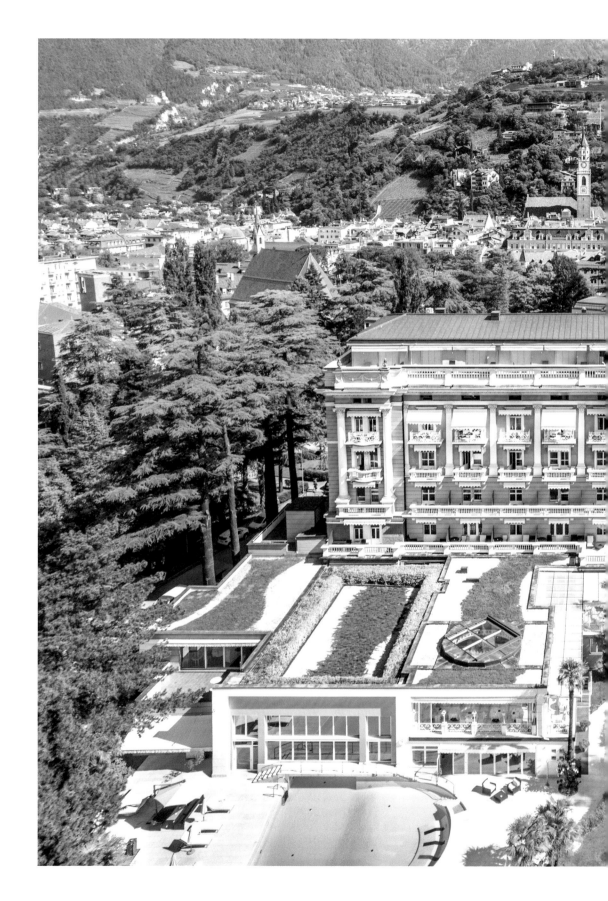

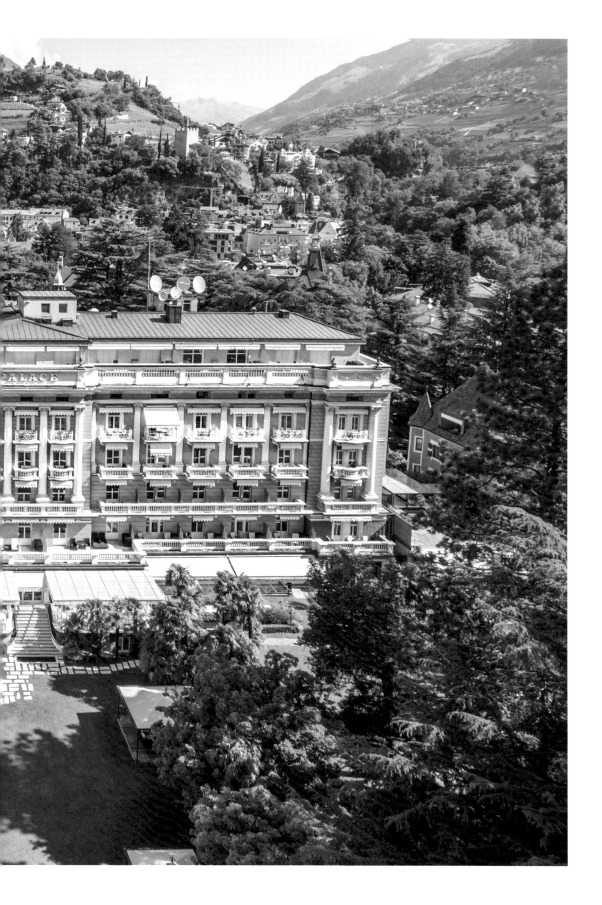

A CONTEMPORARY
HERMITAGE

The Eremito Hotelito del Alma offers a spiritual retreat with all mod cons, totally disconnected from the rest of the world and a mere two hours from Rome.

The owner, Marcello Murzilli, didn't hesitate to buy the entire valley to build a luxury hotel designed as a contemporary hermitage. His aim was to replicate the sober atmosphere of monasteries conducive to contemplation and digital detoxification. Lost in the hills of Umbria, Eremito invites its guests to enjoy silence and spiritual reconnection, far from the hustle and bustle of the city and, above all, far from the internet.

 EREMITO HOTELITO DEL ALMA

+39 0763 891 010

eremito.com
info@eremito.com

The place is designed to be telephone-free, WIFI-free and virtually network-free. Sleek furnishings, Berber-chic decor, candlelight atmosphere – everything is minimalist, but beautiful.

The individual rooms, known as *celluzze* (cells), are reminiscent of the austere cloisters of bygone days. Stripped of anything superfluous, they provide all necessary comforts but without phones or TV. It's time for introspection.

By definition, introspection is an invitation to look inside ourselves to better understand who we are and to take a step back. To reconnect with your inner life, you need to take time and be in the right setting.

By definition, introspection is an invitation to look inside ourselves to better understand who we are and to take a step back.

The vegetarian meals are prepared with produce from the garden and served in silence in the dining room. With Gregorian chants playing in the background, the experience is reminiscent of a monastic refectory.

Days in this secular, stylish monastery, with its meditative aura, are punctuated by walks, spa treatments, yoga classes, tending the vegetable garden, singing workshops (again, Gregorian) or an introduction to icon painting.

Solo travellers who want to break away from the daily grind, escape the digital dictatorship or simply relax will enjoy coming to this calm setting worthy of the gods for as long as it takes to get back to basics.

The experience also has the luxury of being affordable and the hotel regularly hosts weekend and week-long retreats on a variety of themes: yoga, meditation, naturopathy, strengthening your intuition, learning to manifest and so on.

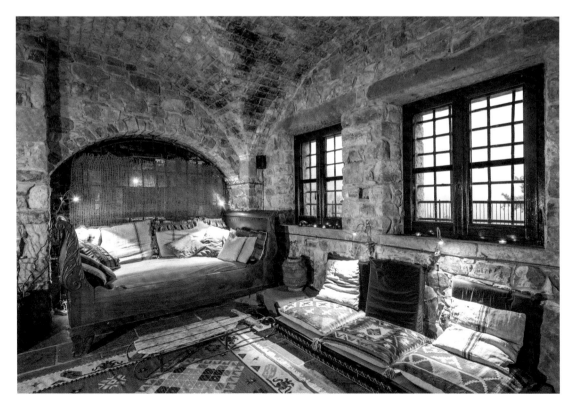

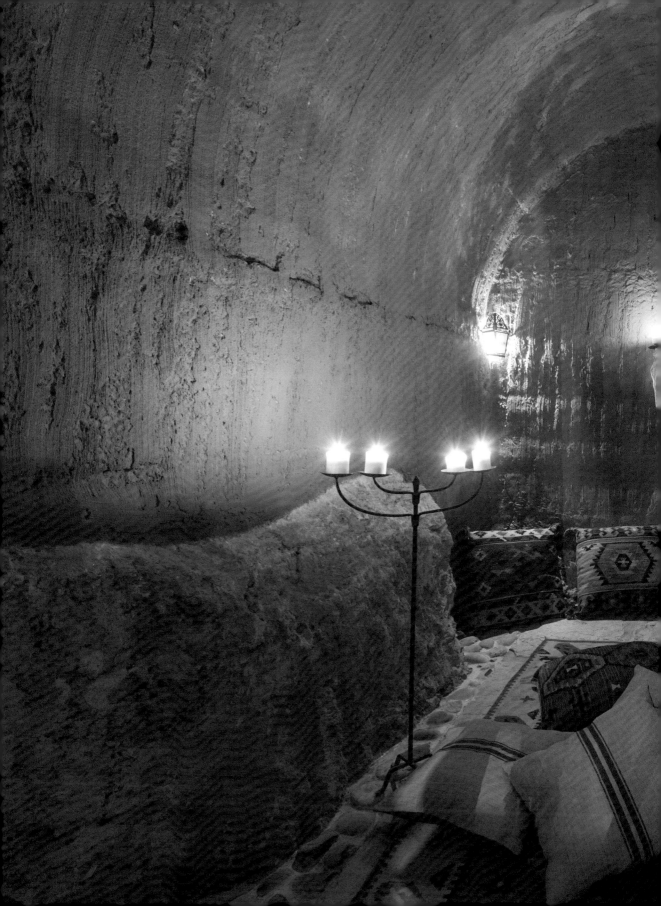

CASA DI SALE

SARDINIA, ITALY

A SILENT RETREAT IN SARDINIA

Although Sardinia is an ultra-popular destination in the Mediterranean that lives to the rhythm of trendy seaside resorts and swarms of tourists, especially in summer, there are still some secret addresses and wild places where nature is perfectly preserved on this beautiful Italian island.

One such place is San Pietro, a small island off the south coast of Sardinia. Here, a boat takes you out for the day to discover the island's cliffs, emerald waters, immaculate beaches and luxuriant scrubland scented with myrtle, eucalyptus and thyme. The founders of Casa di Sale fell in love with this little corner of paradise.

**CASA
DI SALE**

+39 335 605 7177

casadisale.com
casadisale@yahoo.it

© PICASA

© PAOLO BECCARI

© PAOLO BECCARI

© PAOLO BECCARI

Casa di Sale is nestled in Gioia, fifteen minutes from the picturesque village of Carloforte, the island's only inhabited centre. The rural house transformed into a bed & breakfast offers visitors the chance to disconnect from everyday life, far from any noise or urban pollution, and to devote themselves to yoga for a weekend or a week.

From dawn to dusk, Casa di Sale's programmes combine asanas, pranayamas, meditation and Ayurvedic treatments with excursions and boat tours around the island. The temperament of the locals, the volcanic energy (you don't need to know anything about it to feel it almost instantly) and just adapting to a simpler life invite mindful silence. In fact, it quickly takes over from small talk, and deep reflection replaces mental ruminations.

We know that silence has many benefits in combating stress, anxiety and depression but it also improves concentration, mental clarity and creativity.

A stay at Casa di Sale is a wonderful initiation before embarking on a full silent retreat.

This cosy place has limited capacity – only four bedrooms and a few luxury tents – for guests wishing to live to the rhythm of nature and the sun, which they are invited to do regardless of whether they practise salutations or not. Casa di Sale is currently only open from mid-May to mid-October.

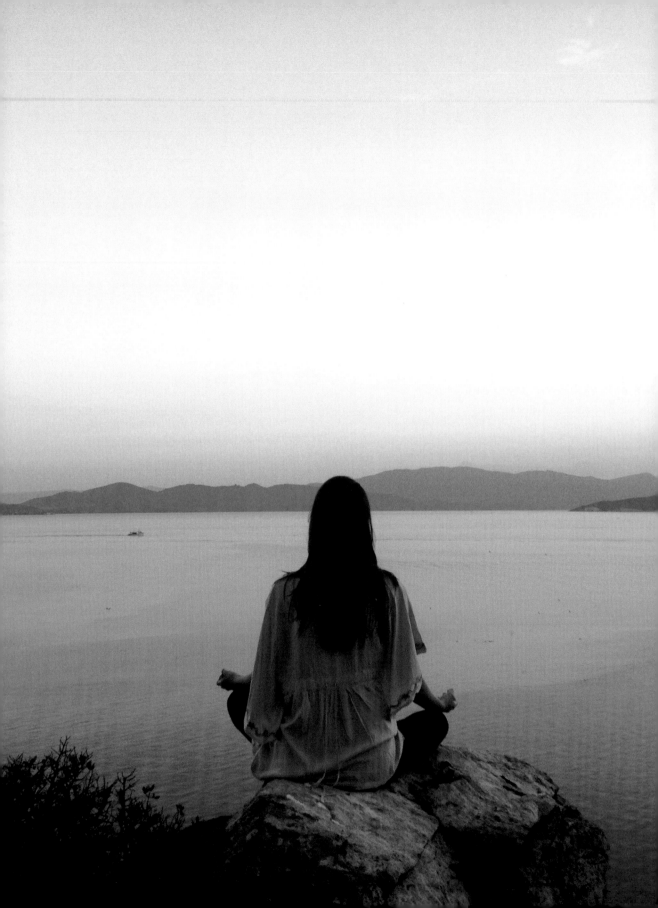

SILVER ISLAND YOGA

GREECE

A YOGA RETREAT
ON A PRIVATE ISLAND

For those dreaming of escaping to a private island, the Silver Island Yoga retreat in Greece is a blessed opportunity. Imagine pebbled beaches, secret coves and long trails across a fragrant islet in the Aegean Sea overgrown with pine and olive trees, and with only four built structures: two traditional houses, a church and a lighthouse.

 SILVER ISLAND YOGA

+230 5 7943699

silverislandyoga.com
retreat@silverislandyoga.com

This retreat was created by the Christie sisters, Claire and Lissa. After inheriting the island, they decided to transform the dilapidated former family home into an exclusive off-grid yoga eco-retreat, with no running water or electricity. Here, only solar energy is used to light and heat the water collected in winter.

Every week from June to October, the two sisters welcome around ten people to their private island.

Doing yoga surrounded by nature fills the body with the energy of prana – the 'vital principle' that animates all life.

There are open-air yoga classes twice a day, at sunrise and sunset, facing the ocean and in the shade of an olive tree. The sessions are taught by hand-picked international teachers, chosen only on recommendation and different at each retreat.

The rest of the time, guests can practise shiatsu with the resident therapist or borrow kayaks, diving equipment and pedalos. Here, you can relax and enjoy vegetarian dishes and organic wines to the sound of cicadas as you gaze out at the crystal-clear sea.

Make no mistake, Silver Island Yoga is not just another billionaire's retreat: prices start at €1,700 per week, all-inclusive.

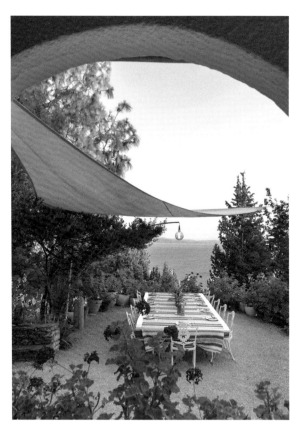

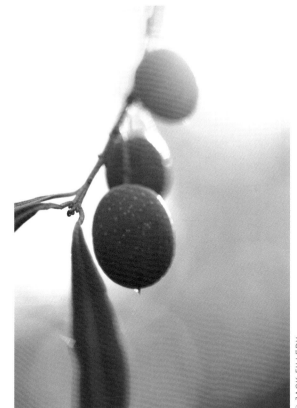

© JACK FILLERY

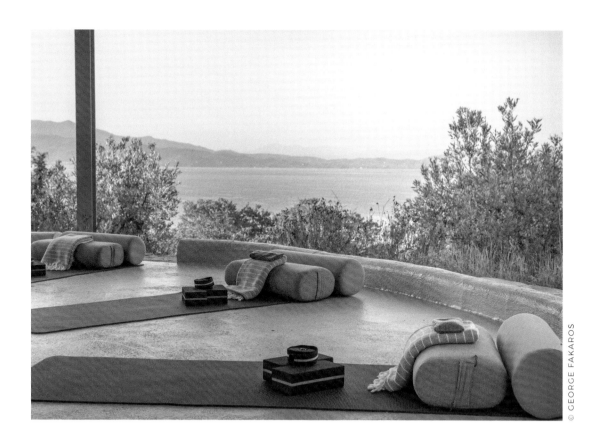

© GEORGE FAKAROS

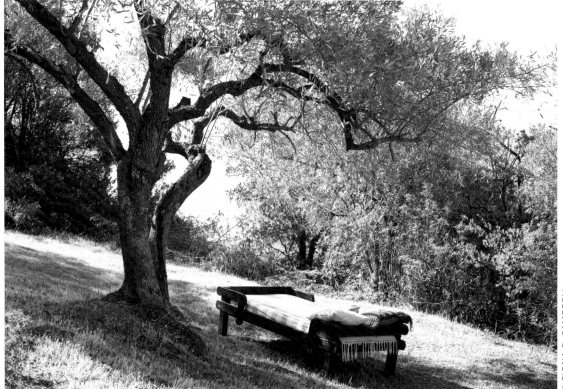

© FIONA E. CAMPBELL

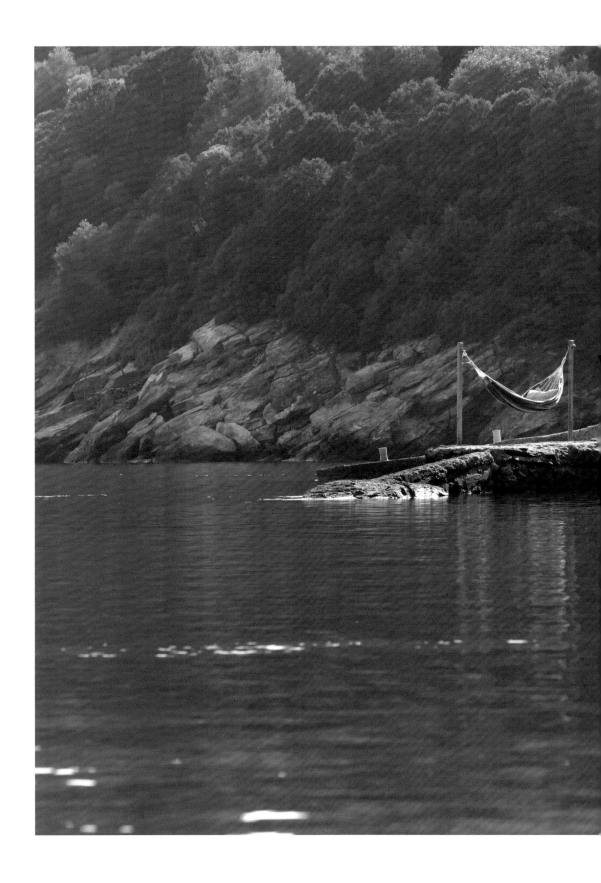

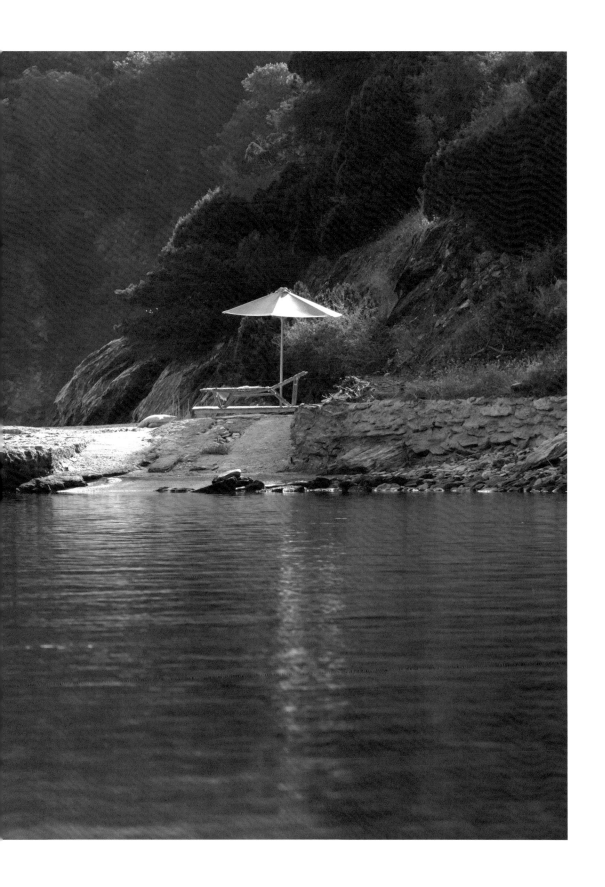

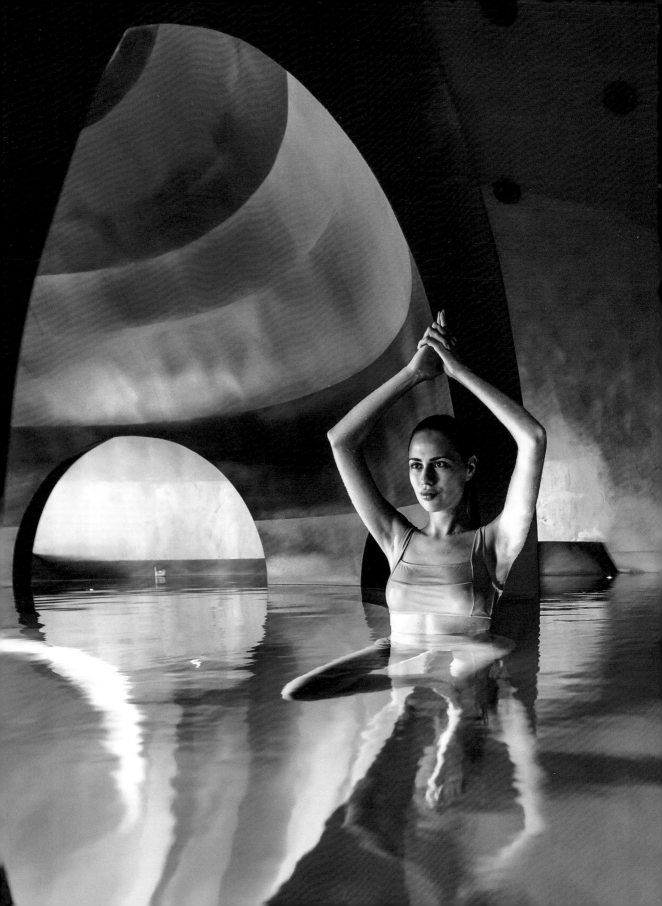

EUPHORIA RETREAT

PELOPONNESE, GREECE

AN ESOTERIC
RETREAT

The name of this new resort immediately sets the tone: Euphoria Retreat claims to be Europe's first five-star spa hotel entirely dedicated to wellbeing.

Set in the unspoilt nature of the Peloponnese, nestled beside a private forest overlooking the UNESCO World Heritage town of Mystras, this holistic centre designed by Marina Efraimoglou positions itself as a place of healing and transformation.

**EUPHORIA
RETREAT**

+30 2731 306 111

euphoriaretreat.com
reservations@euphoriaretreat.com

© STAVROS HABAKIS

© STAVROS HABAKIS

After suffering burn-out in her finance job, founder Efraimoglou decided to organise health and fitness retreats less than three hours from Athens. The concept of her retreats is a skilful combination of Taoism and traditional Chinese and Hippocratic medicine aimed at restoring mental and emotional balance.

For three, five or seven days, guests are invited to follow the path to freedom through a wide choice of programmes, themes and disciplines (physical and emotional transformation, shamanic healing, Qi and Chinese medicine, yoga and mindfulness, detox and weight loss ...).

Here, nothing is left to chance: cellular needs are assessed, personalised eating plans are drawn up and transformational coaching is offered to achieve the agreed-on goals. Throughout their stay, guests are looked after by a team of doctors, spiritual mentors, nutritionists, therapists and fitness coaches.

We know that, in most cultures, water has long been used for its powers of spiritual purification.

To enhance the benefits of the retreat, the luxurious spa (measuring 3,500 sq. km and spread over no fewer than four levels) features an impressive range of water experiences (a Watsu pool, Kneipp therapy, floating sessions to the sound of whale song, and more).

The extensive list of treatments available includes Reiki sessions, chakra realignment and gong baths.

Expect esoteric treatments and pleasures: in this holistic sanctuary, no sacrifices or restrictions are required. There's no reason to say no to a good glass of wine at Gaia, the resort's restaurant that boasts panoramic views.

What is it about this resort? Is it the Byzantine-style architecture, with its arches and arcades, or the many circular elements derived from feng shui? Simply setting down your suitcases in this enchanting setting will lighten your spirits.

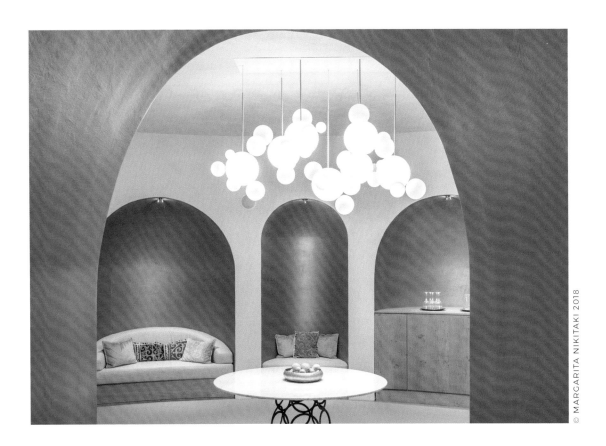

© MARGARITA NIKITAKI 2018

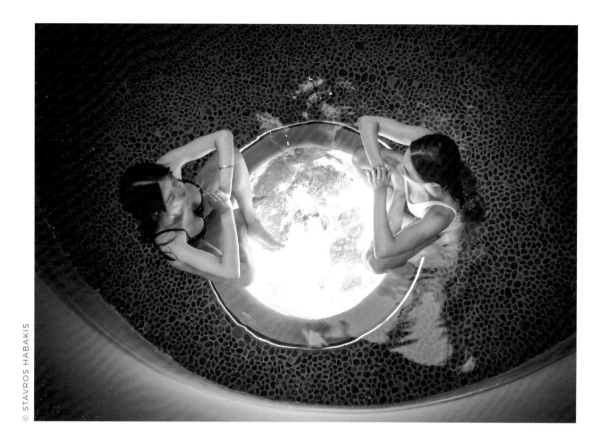

© STAVROS HABAKIS

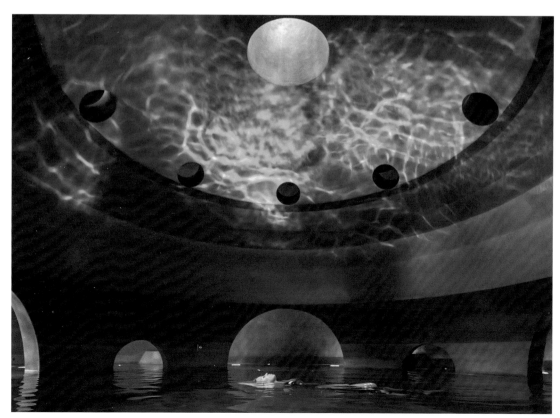

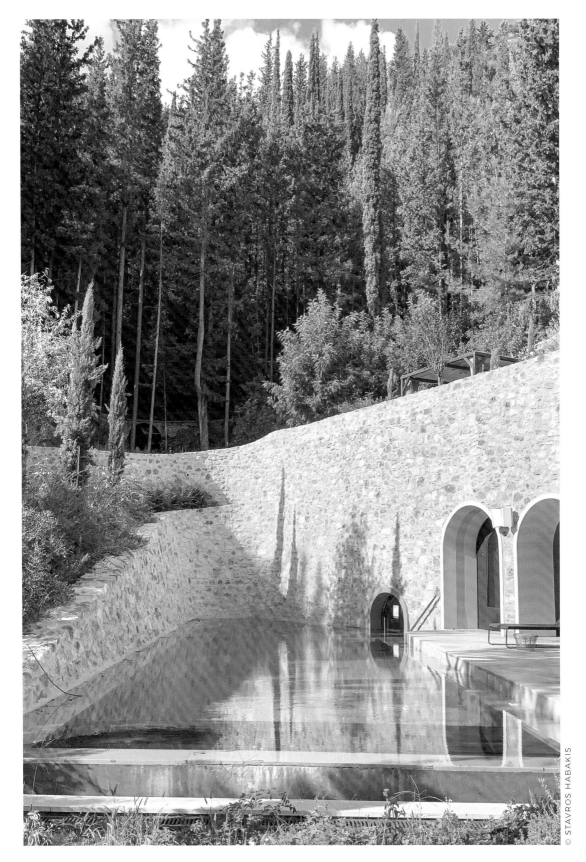

© STAVROS HABAKIS

© STAVROS HABAKIS

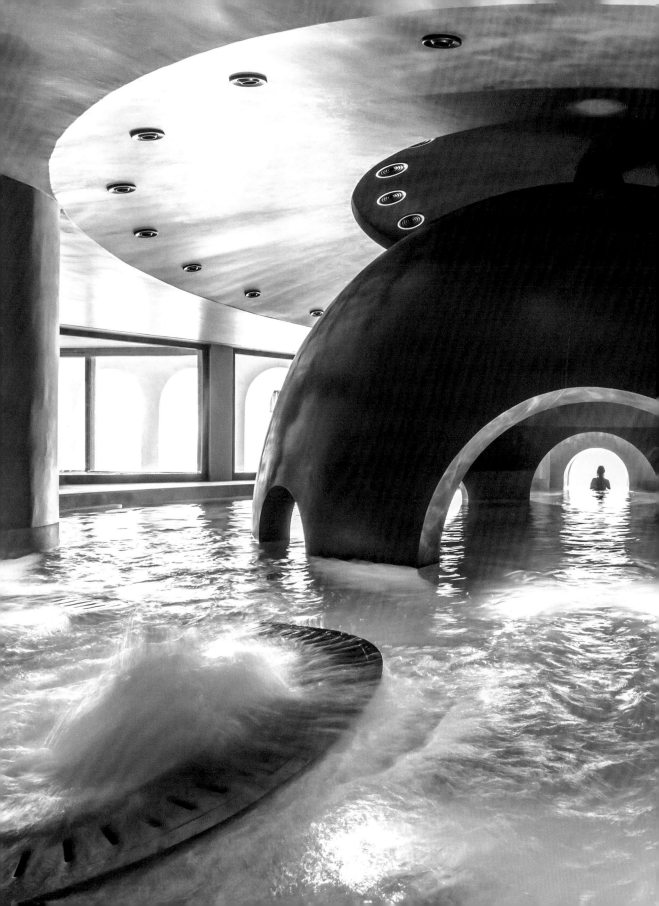

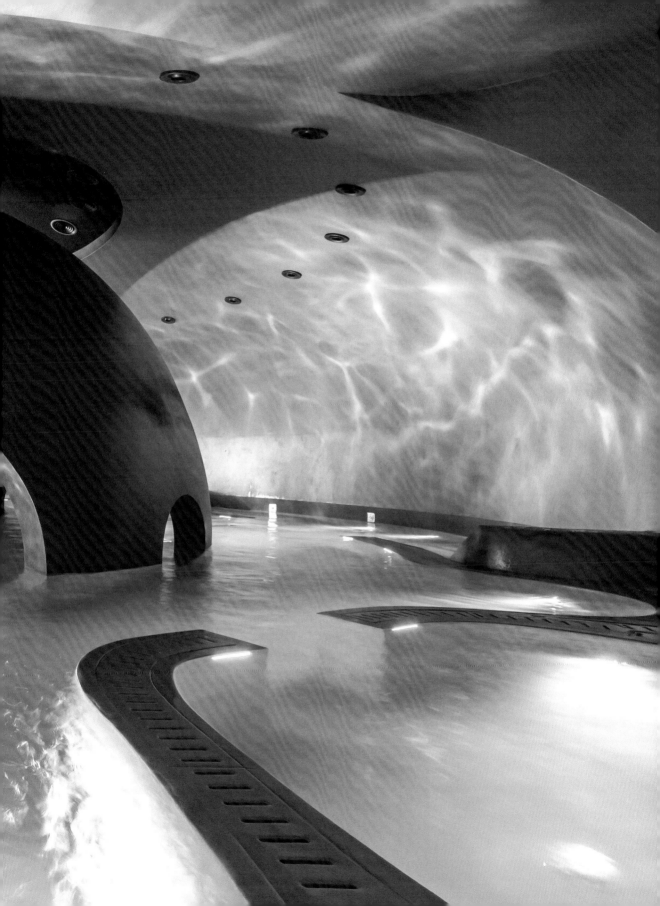

THELIFECO

BODRUM, TÜRKIYE

AN ADVANCED ESTABLISHMENT TO GET BACK INTO SHAPE

Although it's not the most famous, TheLifeCo is among the most advanced establishments to help you get back into shape. The testimonials on their website are fabulous: 'a solution to burn-out'; 'lost four kilos in five days'; 'a gift you give yourself' …

The group has three addresses: one in Thailand (Phuket) and two on the shores of the Aegean Sea in Türkiye (Antalya and Bodrum), where regulars, mostly from Europe, return year after year.

 THELIFECO

+90 533 225 65 50

thelifeco.com
info@thelifeco.com

© EMRE GOLOGLU

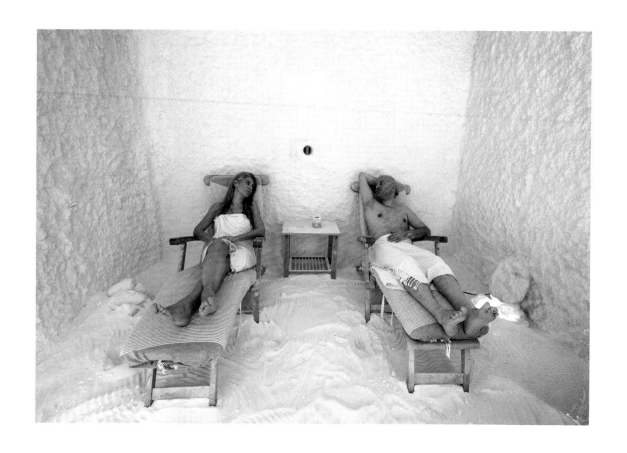

© LARIEN DIJITAL MEDYA / ZEYNEP ISIK

Six different meal plans are available to suit the needs of as many people as possible. For example, the Green Detox diet helps to alkalinise the body and combat acidification caused notably by stress. Then there is the Green Salad Detox programme, which, as its name suggests, comprises salads and intermittent fasting. The programme involves eating within a six-hour window and leaving the body to rest for the other eighteen. Another option is the Keto diet, a plant-based, high-fat, low-carb eating plan.

As for the range of available treatments, it's on a par with those offered by famous clinics in Italy and Germany and includes intravenous vitamin and ozone injections, laser skin treatments and cryotherapy cabins to combat cellulite.

Above all, TheLifeCo stands out for the importance it places on sport. While esoteric practices may be fashionable, it's worth remembering that regular movement is still the best way to re-energise yourself.

At TheLifeCo, it's physical exercise under the Turkish sun that pushes you beyond your limits. Putting exercise back at the heart of the quest for wellbeing is far from pointless, yet it's often forgotten. Guests are encouraged to move around the centre by bicycle instead of using the golf carts. The programmes include group exercise sessions, namely HIIT circuits (HIIT stands for high-intensity interval training and is ideal for burning fat and improving endurance), as well as individual classes designed to tackle issues like lack of vitality and the desire to lose weight. As for the gym, it's gigantic and equipped with all the latest machines.

The *GetFit & Healthy* programme combines targeted training, infrared sauna sessions to recover, a protein-rich diet and post-workout massages.

PHOTOS © FABRICE COIFFARD

THE YOGI SURFER

NEAR AGADI, MOROCCO

FIND
YOUR FLOW

Although body care and beauty rituals are deeply rooted in Moroccan culture, 'wellbeing' as we know it today is not necessarily associated with this country ... except in the bay of Taghazout. This small fishing village a few kilometres from Agadir, the cradle of surfing in Morocco, is one of the most popular spots on the Atlantic coast and a well-known destination for yogis.

**THE YOGI
SURFER**

+212 6 53 97 44 56

theyogisurfer.com
contact@theyogisurfer.com

Most of the small hotels lining the main street offer courses but The Yogi Surfer, located at the top of the village of Tamraght and facing the ocean, is the village's focal point. All year round, this eight-room boutique hotel welcomes fans of surfing and yoga. The day begins at sunrise with pranayama and Vinyasa yoga sessions on the roof terrace. It continues on the beach, with surf lessons given by the region's best instructors and occasional visiting international stars.

Whether you're a beginner or an experienced surfer, you can enjoy the swell and try surf sessions that vary in intensity depending on your level. Surf fans can even try their hand at surfing on the sand dunes.

Practising yoga improves balance on the board, concentration, strength and flexibility.

According to experts, yoga and surfing are two disciplines that seem to have been created to complement each other: each brings specific benefits and together they create a perfect harmony.

Practising yoga improves balance on the board, concentration, strength and flexibility. As for surfing, it requires balance, strength and flexibility. Yoga strengthens core abdominal and back muscles, which are crucial on the waves, while breathing exercises (pranayama) help to develop the concentration and clarity of mind needed to face the challenges of the ocean. All this is taught in a very friendly atmosphere at The Yogi Surfer.

After the effort, the reward: vegetarian meals are cooked every evening by Moroccan chefs and the atmosphere is always festive. Prices at The Yogi Surfer are very reasonable.

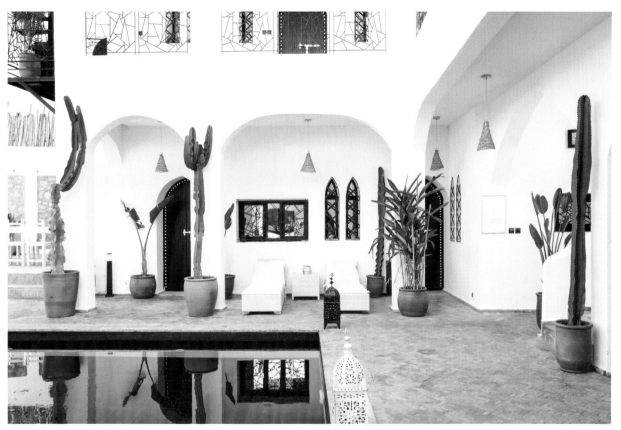

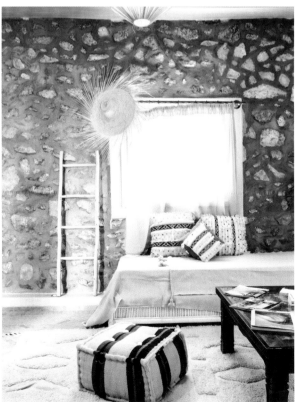

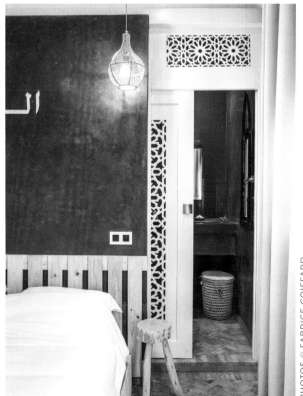

PHOTOS © FABRICE COIFFARD

BLISS & STARS

SOUTH AFRICA

STARS
IN YOUR EYES

To quote the founders: '*At Bliss & Stars, we fuse nature, meditation, movement, food, and astronomy to guide you into presence and stillness. We curate experiences that inspire people to slow down, meet themselves as they are, and experience more joy and wholeness in life.*'

On paper (and on their website), Bliss & Stars has it all ... as anyone who has stayed in one of their minimalist chalets overlooking the Cederberg mountains of South Africa will confirm.

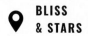

**BLISS
& STARS**

+27 21 813 9734

blissandstars.com
hello@blissandstars.com

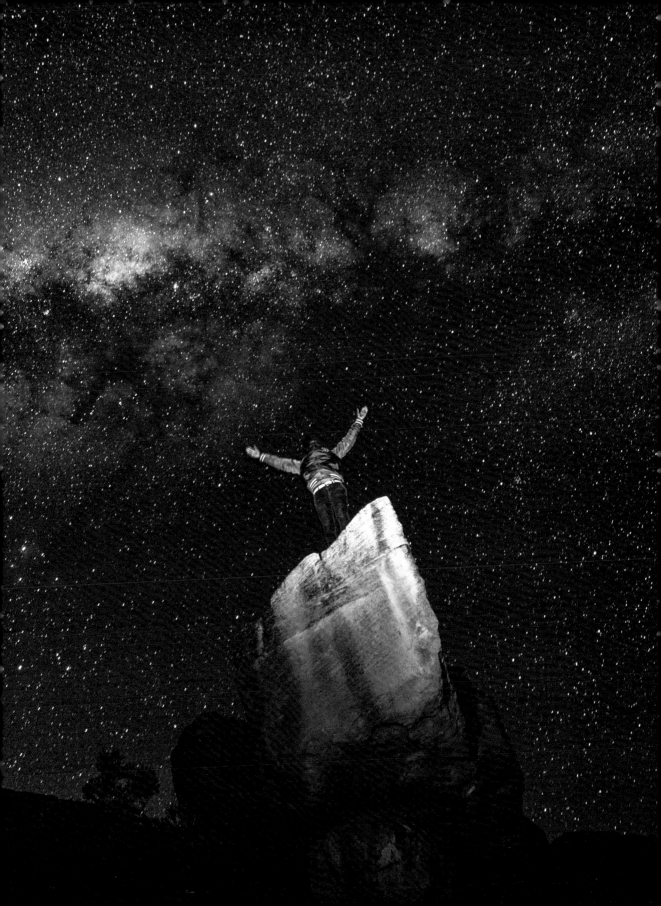

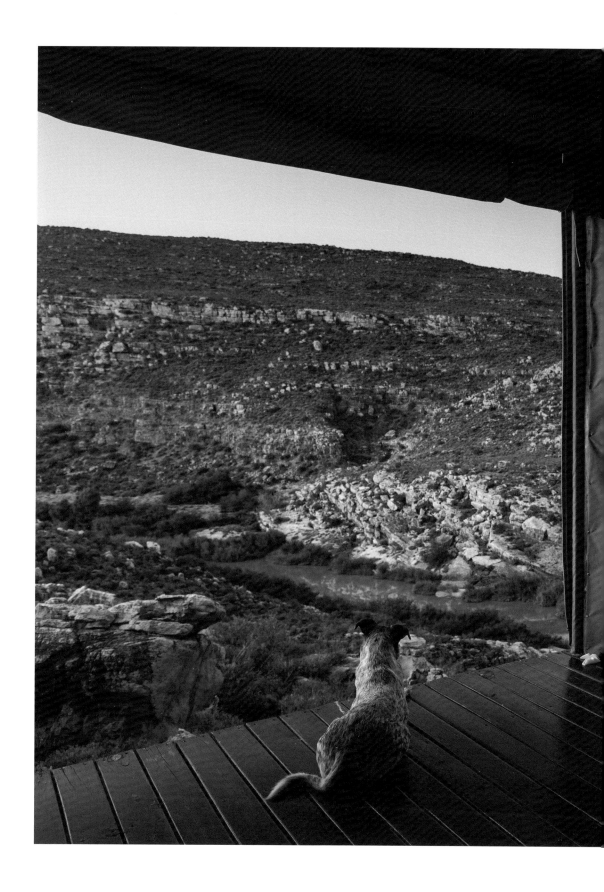

© TEAGAN CUNNIFFE

191

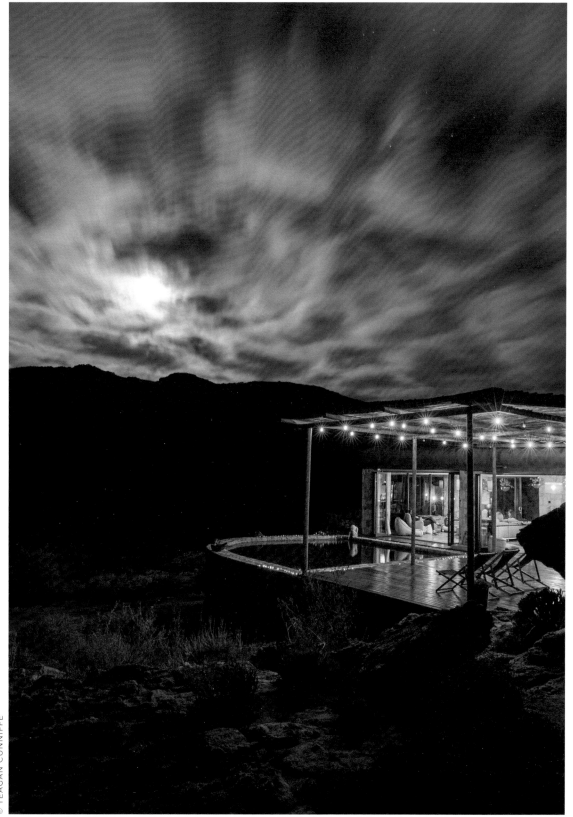

© TEAGAN CUNNIFFE

Located about three and a half hours from Cape Town and with no distractions for kilometres around, this is a hiker's paradise and an ideal destination in which to disconnect.

Programmes last between four and seven days and tackle various themes. There's a silent retreat, a couple's retreat, a women's retreat, a self-compassion retreat and more.

The yoga, breathwork and mindfulness (through meditation but also through cooking and walking) are all enhanced by being practised under the stars. The climate and absence of visual pollution make Bliss & Stars an exceptional place to observe the starry sky, both with the naked eye and with a telescope (the hotel will lend you one). Try your hand at astronomy or a photography course. Learn to locate constellations or simply take a bath under the stars …

Whether we're talking about the cosmos, energy, mythology, fables or science, an increasing number of studies confirm that being connected with nature has a strong correlation with wellbeing.

No matter how old you are, there is a universal sense of fulfilment when you look at a sunrise, a sunset, a rainbow or a starry night.

When you see the breathtaking spectacle of nature that occurs every evening at Clanwilliam, you will realise that you need very little to live your best life. Forget about mantras, a special diet or a set of crystals …

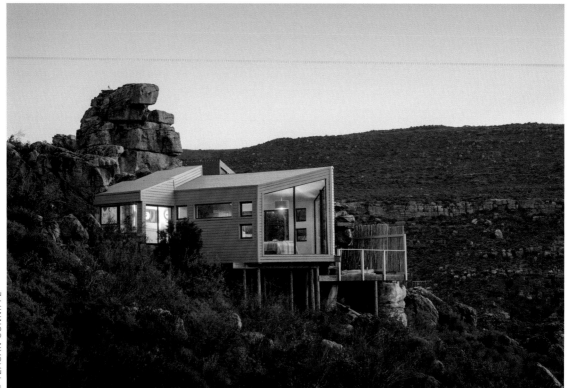

© TEAGAN CUNNIFFE

© TEAGAN CUNNIFFE

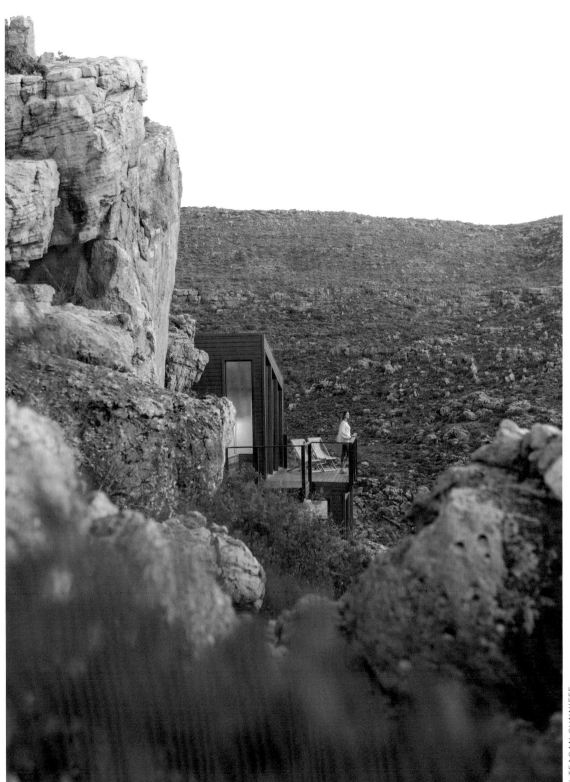

© TEAGAN CUNNIFFE

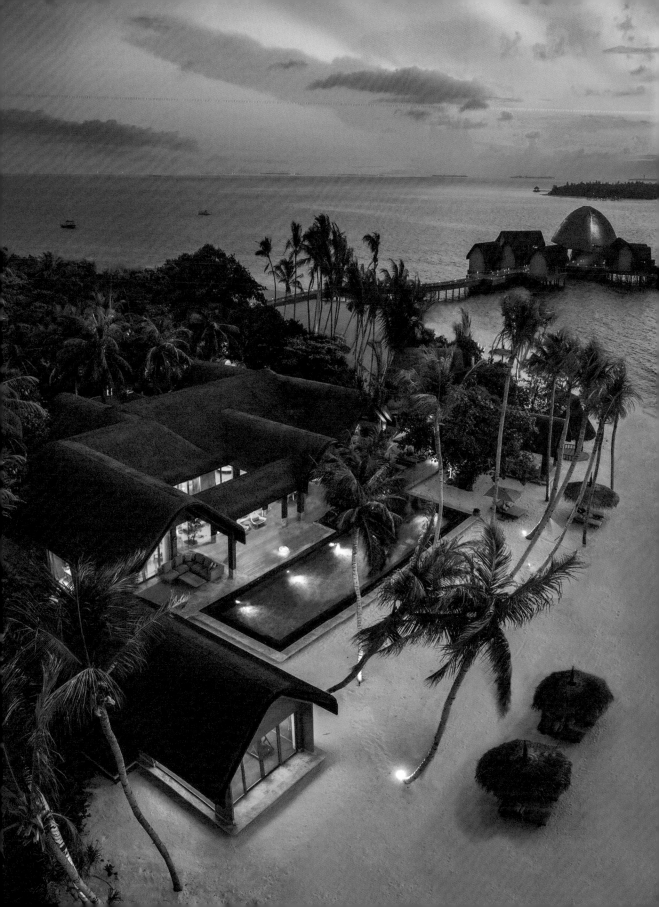

JOALI BEING

MALDIVES

THE FIRST
'WELLBEING' ISLAND

The founders of Joali Being set their sights on the Maldives to carry out the first project of this kind in the world: an entire island devoted to wellness. For years, they tested the most cutting-edge destinations to create their own methods, train their therapists and curate their favourite treatments.

The result is a giant spa on a (natural) island in the atoll of Raa. Programmes range from five nights to three weeks, blending technology and ancestral disciplines around four pillars: spirit, skin, microbiome and energy.

 JOALI BEING

+960 658 4444

joali.com
info.being@joali.com

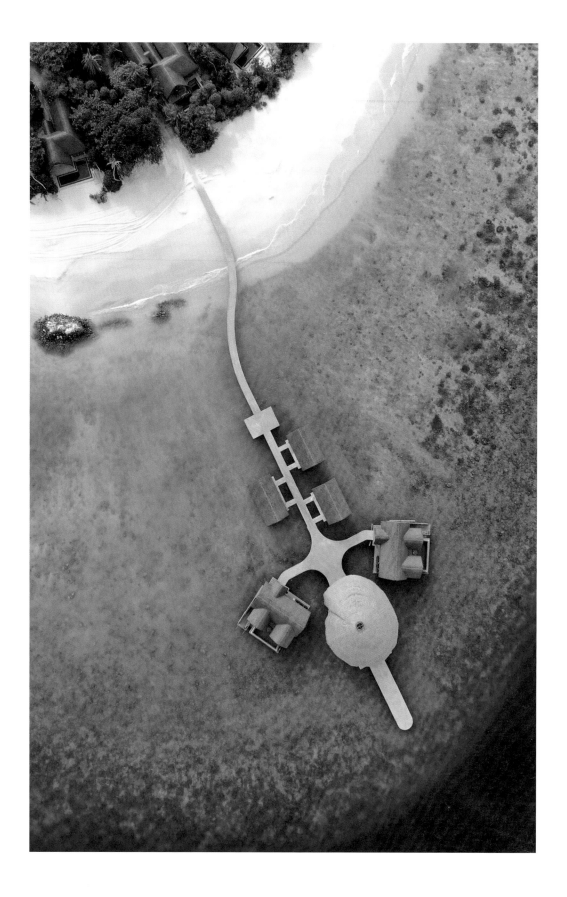

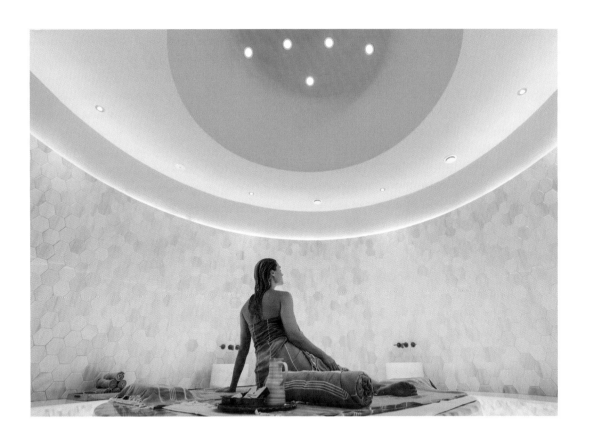

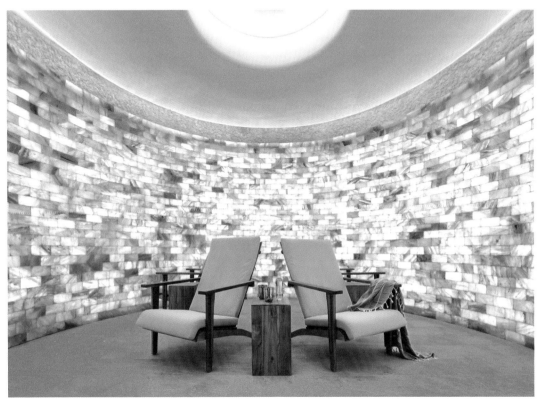

A growing number of scientists are taking an interest in sound therapy and demonstrating that certain sounds have the capacity to reduce anxiety and lift the spirit. Sound healing is at the heart of everything at Joali Being.

Retreats all start with a consultation with a specialist, a few tests and a full prescription of menus, drinks (including a personalised tea made in the hotel's herbalist shop), activities and treatments.

Along with an extensive menu of activities, the facility has an anti-gravity yoga pavilion, a salt room, a cryotherapy cabin (the first in the region), a state-of-the-art gym (equipped with interactive mirrors for guided training and biofeedback using immersive virtual reality) and breathwork sessions. But above all, sound healing is everywhere here: from the dedicated pavilion, to massages with gongs, tuning forks and chimes, to the sound path (a walking trail equipped with instruments to make each chakra vibrate as you walk along it) and the musical accessories available in the villas.

The lucky few who can say they've had enough of Swiss clinics can take advantage of winters in the Maldives to improve their mental clarity, restore their sleep, boost their immune system or rebalance their digestive system. What else makes this retreat stand out? The fact that it's conceived on biophilic design principles, a new trend in design that seeks to reconnect users with nature. You can feel it at almost every step …

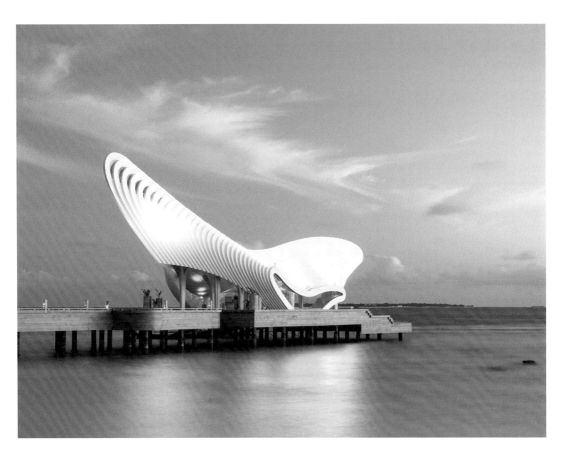

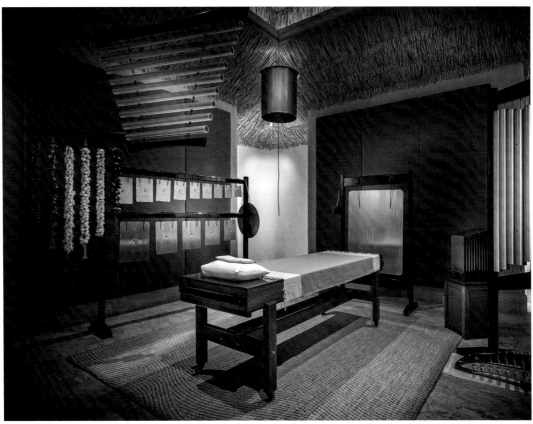

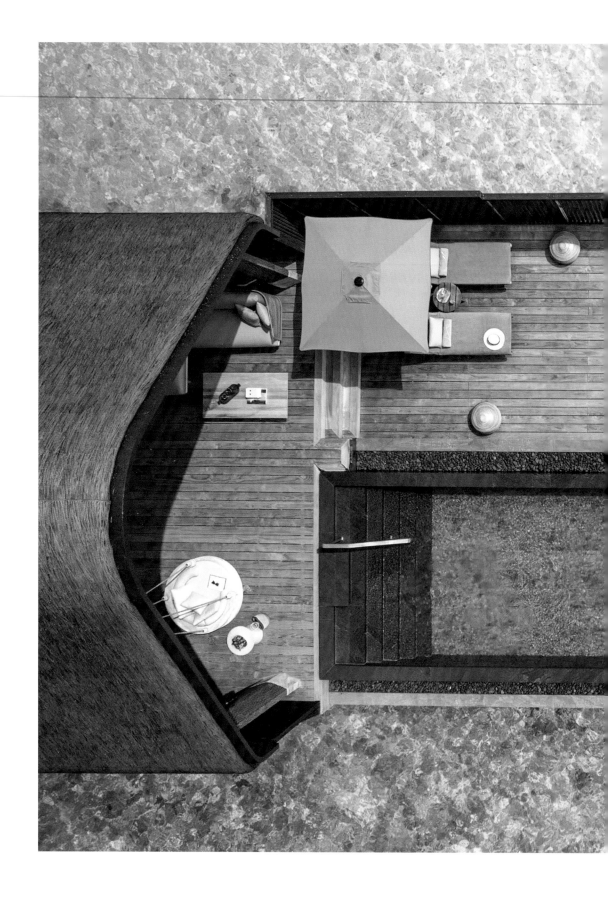

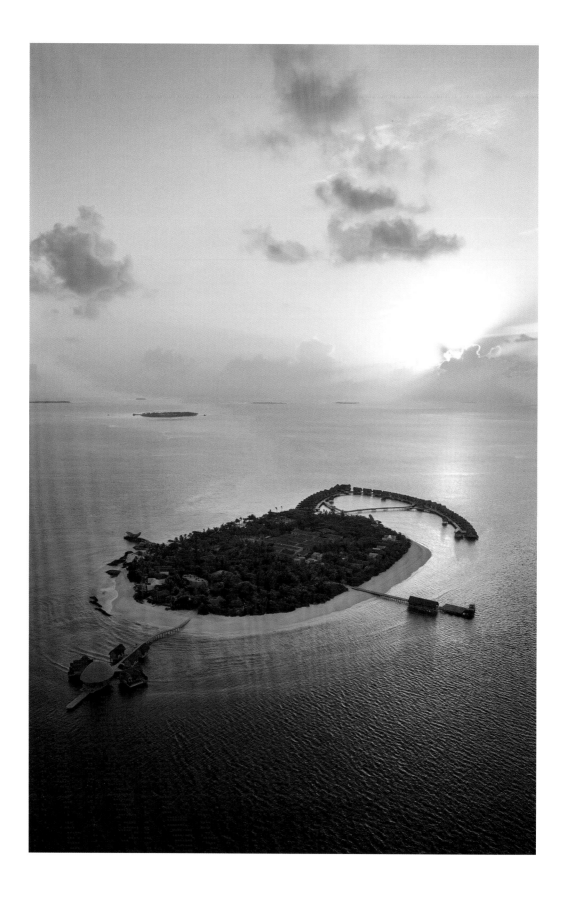

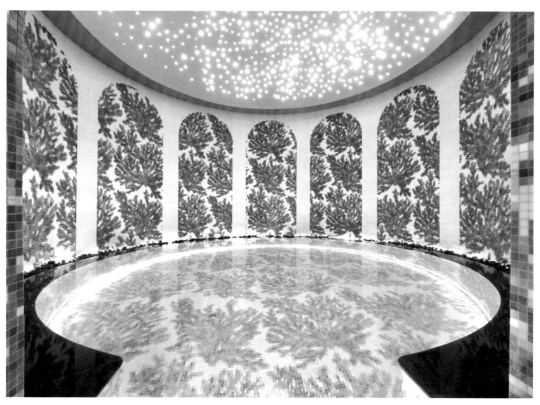

SOMATHEERAM AYURVEDIC HEALTH RESORT

KERALA, INDIA

INDIA'S BEST
AYURVEDIC CLINIC

The state of Kerala, on the south-west coast of India, is home to beaches, palm trees, national parks and a swarm of Ayurvedic clinics. But of all the insider destinations, only one has been making headlines for more than ten years. Located in lush nature (both an integral part of reconnecting with oneself according to traditional Indian medicine and a generous source of medicinal herbs), the Somatheeram Ayurvedic Health Resort regularly wins awards for the professionalism of its therapists and the quality of its programmes and traditional cottages.

 SOMATHEERAM AYURVEDIC HEALTH RESORT

+33 6 30 34 53 28

somatheeram.org
info@somatheeram.org / europe@somatheeram.org

© BENJAMIN KURTZ

© BENJAMIN KURTZ

Ayurveda is based on maintaining a constant balance in order to become and remain healthy, in harmony with our environment. Recognised by the World Health Organization as a traditional medicine since 1982, it is based on the principle that illnesses are caused by imbalances. Bad lifestyle habits, stress, exhausting work and/or an unsuitable diet gradually results in a deterioration of the original state of health. All the packages in this traditional clinic are designed with Western pathologies in mind: rejuvenation, body purification, stress management and slimming.

Upon arrival, a doctor will take the patient's pulse, observe their tongue, morphology and skin to establish their constitution (known as the *dosha* in Ayurveda), their diet (vegetarian only), the herbal concoctions they will drink and the massage best suited to them.

Treatments last between seven and seventeen days and during this time, nothing is compulsory, although some strong recommendations are made, including: meditation at sunrise, yoga classes at 7.30am and daily massages with sesame or coconut oil. Massages here are very different from what we are used to in the West. They feel enveloping and maternal and can be quite a surprise for Westerners. The eyes are cleaned with natural drops, the nose with oil and the ears with herbal steam.

Each day follows the same pattern. The procedures are not necessarily explained but this is what allows you to let go. The first few days may result in headaches and extreme exhaustion until the Panchakram cleanse with ghee (clarified butter) and hot water on the fourth evening, which is carried out at bedtime to eliminate toxins and purify the liver. From this point onwards, the detox starts to take effect, energy returns, and calm and clarity of mind are restored.

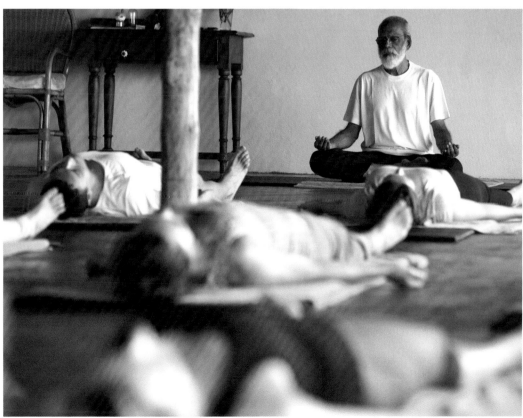

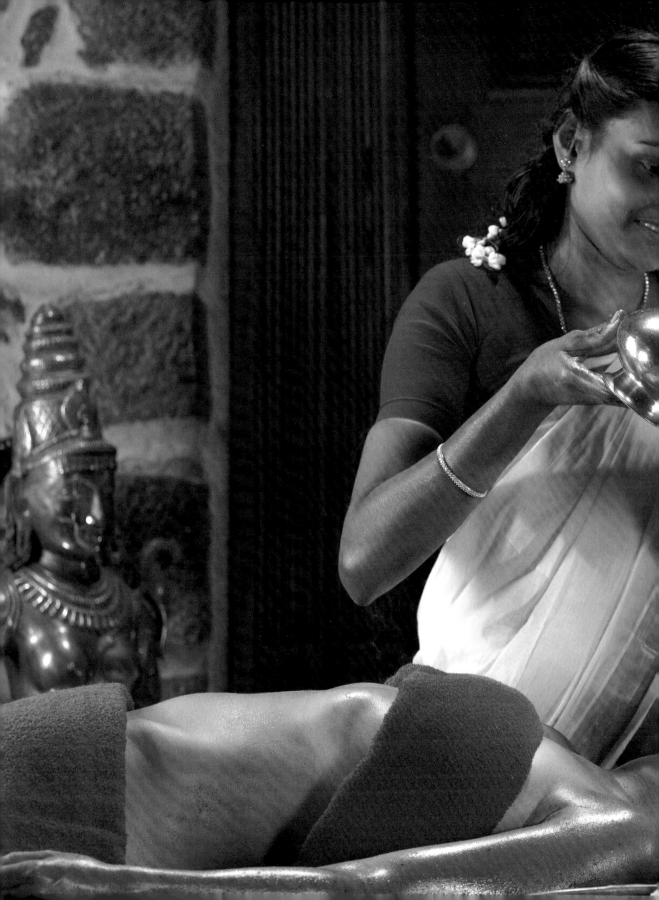

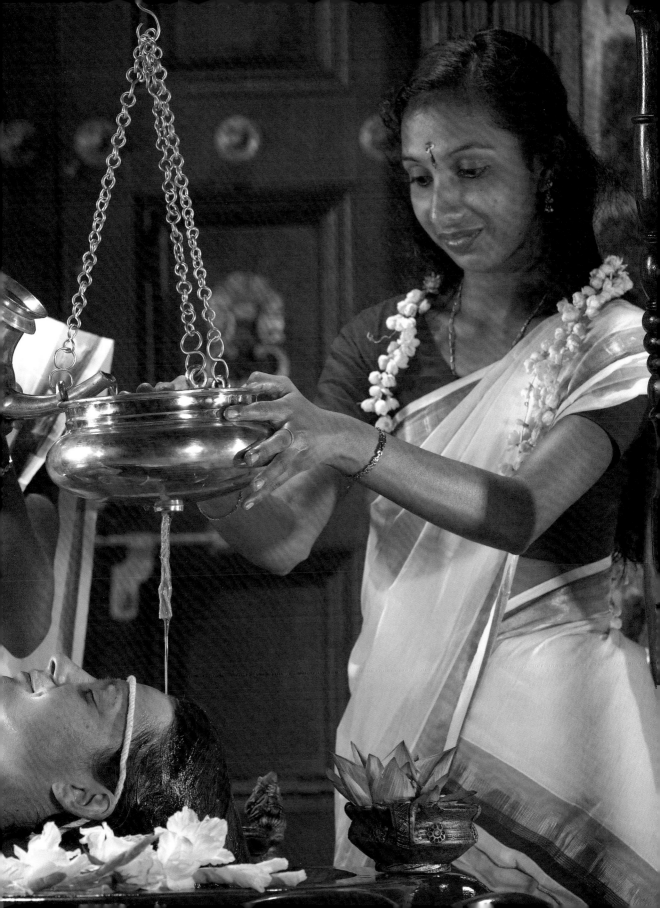

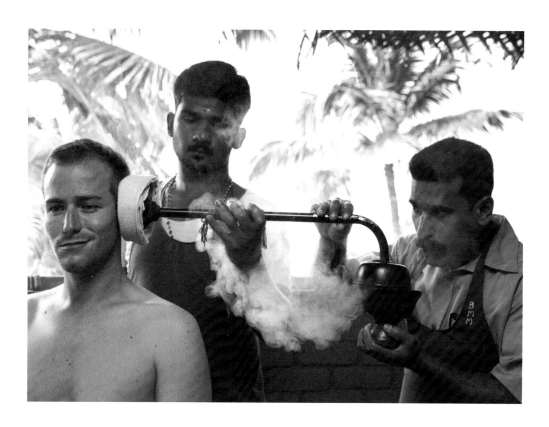

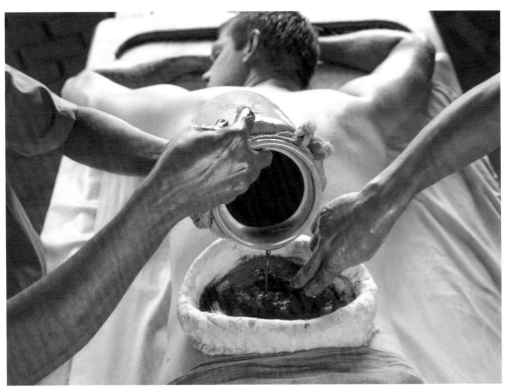

ANANDA

HIMALAYAS, INDIA

(RE)DISCOVERING YOGA
FACING THE HIMALAYAS

If you're going to India, you might as well think big. Perched high above Rishikesh, the city of sages, yogis, the Ganges and ashrams, Ananda provides an experience that transcends the ordinary. Its natural setting offers breathtaking views of the sacred Himalayan mountains. Waking up every morning to such a spectacle is a source of physical and mental regeneration in itself.

Its discreet luxury makes Ananda an architectural jewel that combines the splendour of traditional Indian design with the comfort of modern facilities. And finally, its wellness programme – regularly acclaimed by the international press – is a must.

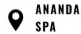 **ANANDA SPA**

+91 80 69750000

anandaspa.com
reservations@anandaspa.com

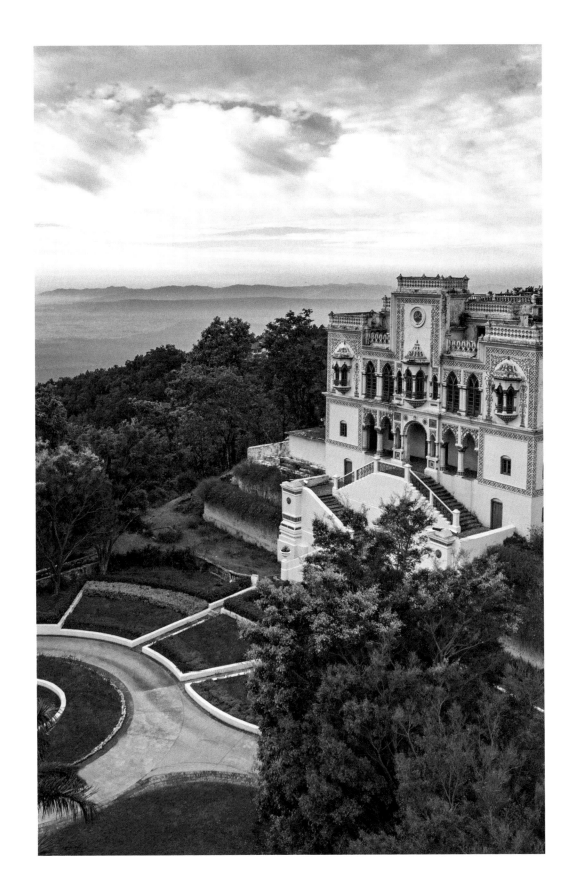

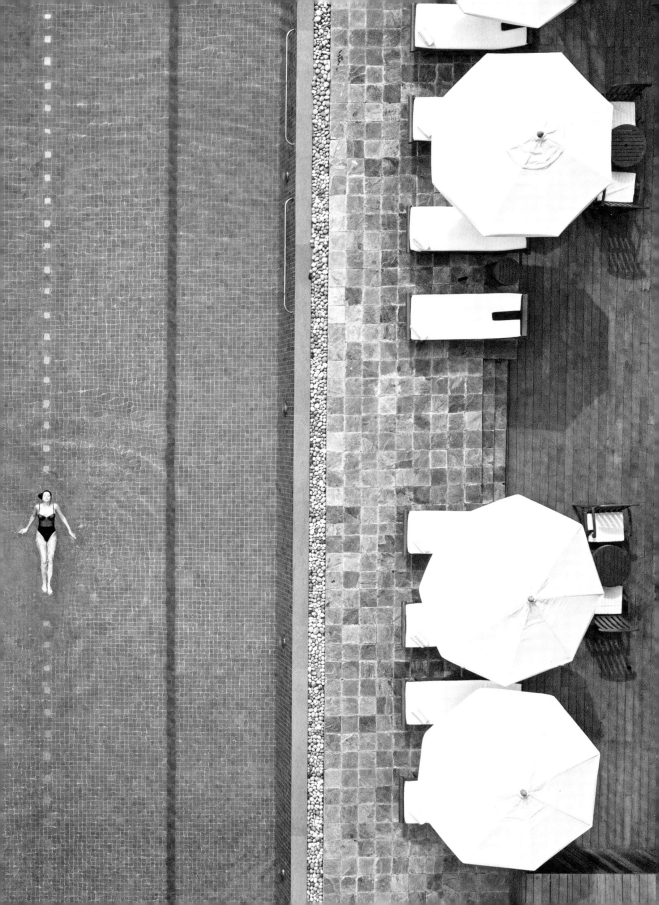

© ROSO PHOTOGRAPHY

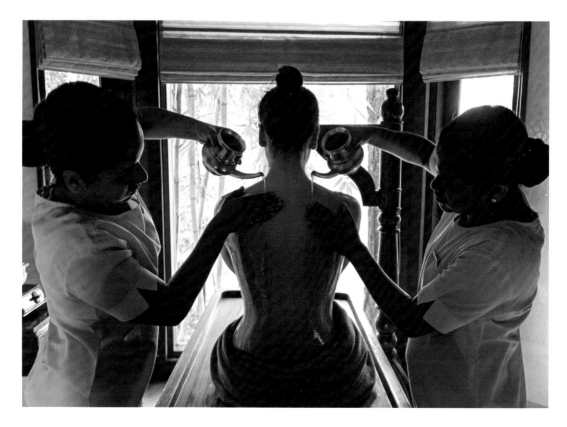

The spa is inspired by Indian traditions and age-old healing methods and staffed by experienced therapists and Ayurvedic experts. Personalised programmes have been revised and updated in line with the latest advances in the world of wellness and include holistic detox, yogic detox, hormone rebalancing, sports fitness, weight loss, stress management and rejuvenation.

The three-week intensive Panchakarma programme follows a three-stage process (based on the guest's Ayurvedic constitution) and is the most natural and complete approach to purification, rejuvenation and deep healing of the body and mind.

Given that Ananda overlooks the yoga capital of the world, it's no wonder the retreat offers yoga in all its programmes. Surrounded by the world's best teachers, this is the place to (re) discover authentic yoga: from Hatha to Gatyatmak (Hatha yoga based on salutations to the Sun and the Moon), pranayama (yoga of breathing) and bandhas (energy locks to stimulate the circulation of energy in the body).

The wellness retreat boasts a yoga pavilion, a meditation area, a state-of-the-art gym and a turquoise swimming pool. The list of available treatments includes ancient rituals as well as infrared sauna sessions, facial rejuvenation and osteopathy.

The staff are extremely attentive and the rooms come with extra amenities (all have a kurta, a traditional cotton outfit). The wide range of activities on offer (including a romantic dinner under the stars, trekking, temple visits and offerings to the goddess Ganga at sunset) complete the wellness experience.

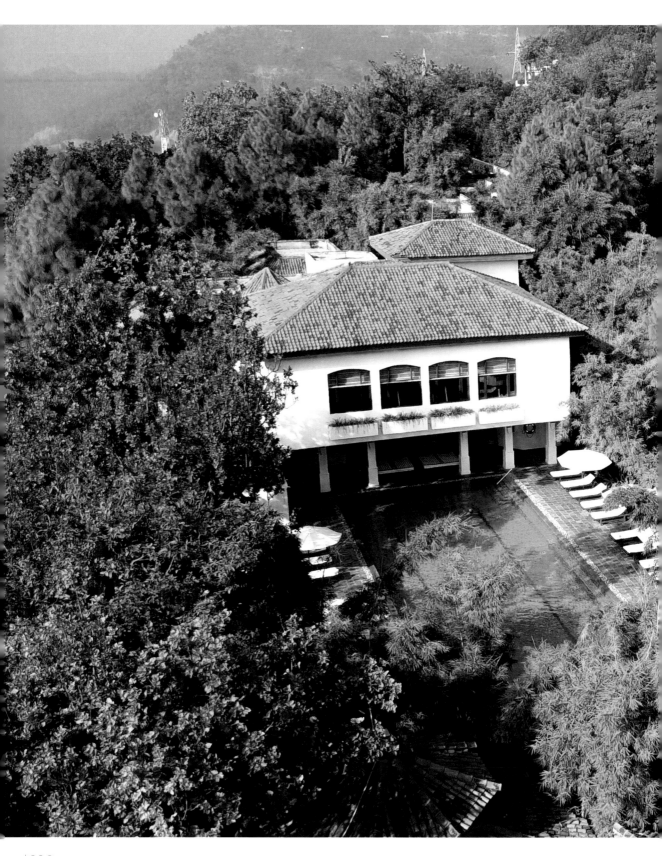

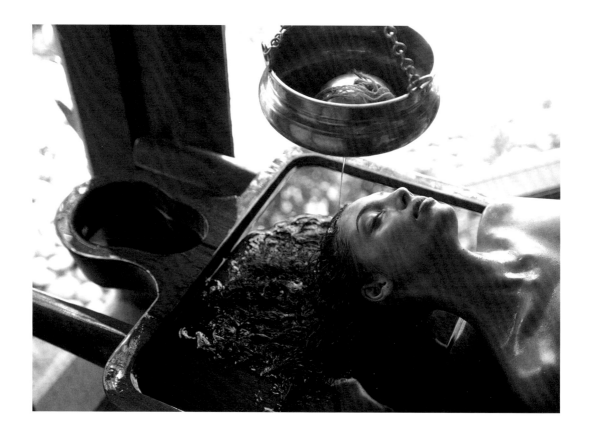

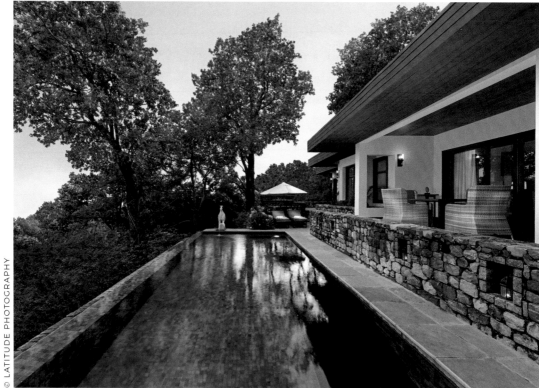

© LATITUDE PHOTOGRAPHY

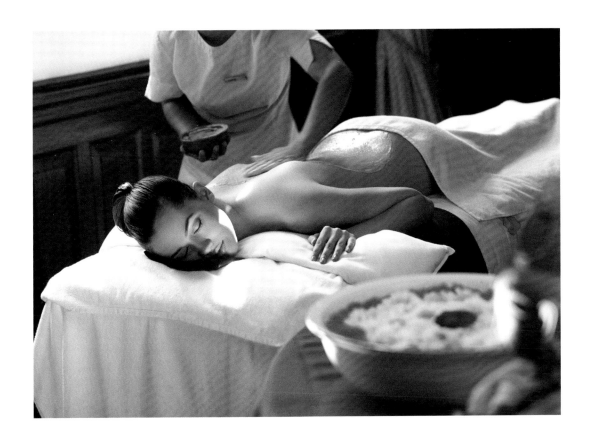

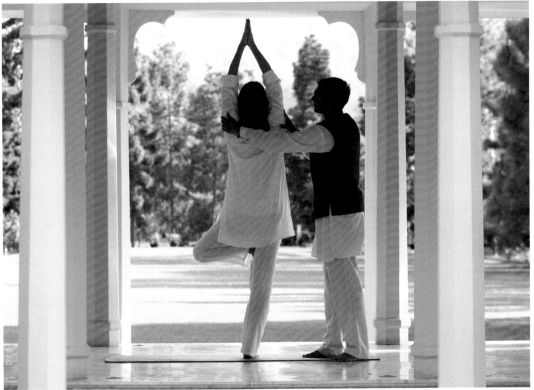

© CHRIS CALDICOTT

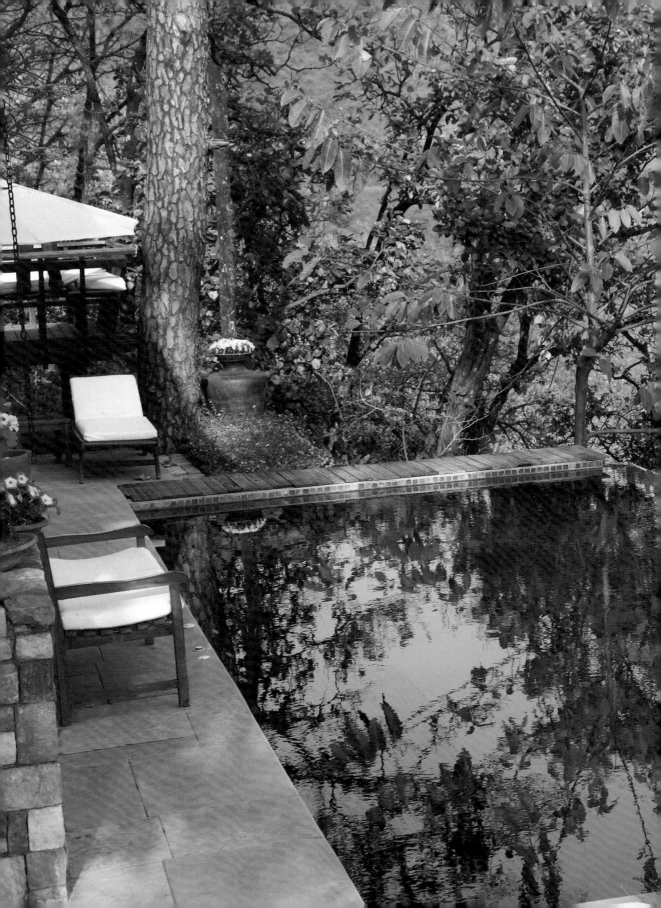

YOGA
IN A LOST PARADISE

Sheltered at the foot of the Galgiriyawa Mountain, which forms the backbone of Sri Lanka, and surrounded by seven hills, Ulpotha was originally discovered by wandering ascetics and has long been a place of pilgrimage.

On a whim, Viren Perera, an investment banker from Colombo, bought an abandoned coconut plantation. Fuelled by his passion to return to traditional farming methods, he set about reforesting the area and rebuilding the ruined manor house and then created a village.

Since then, the Buddhist farming community has opened its doors to guests for part of the year, offering one- or two-week retreats.

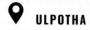 ULPOTHA

+94 77 785 0682

ulpotha.com
info@ulpotha.com

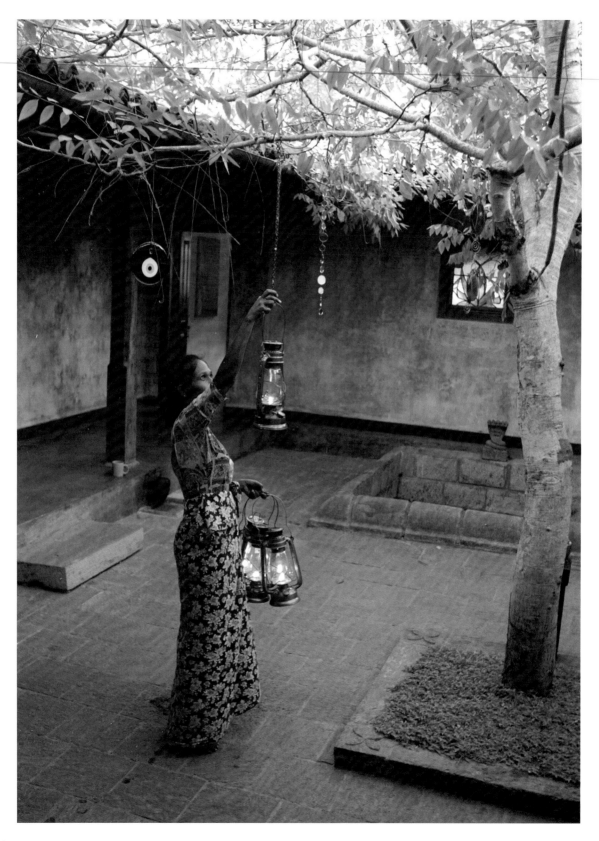

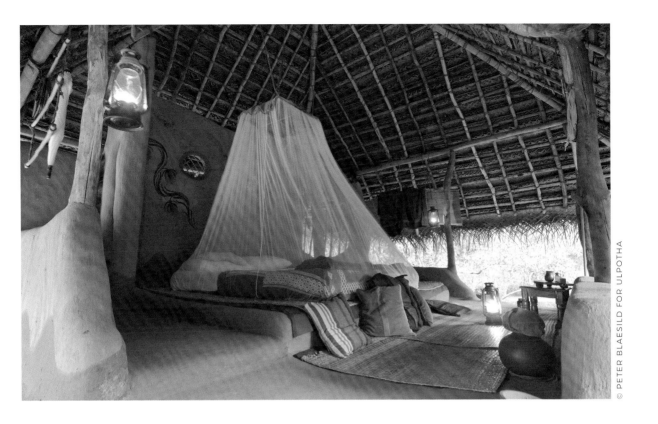

© PETER BLAESILD FOR ULPOTHA

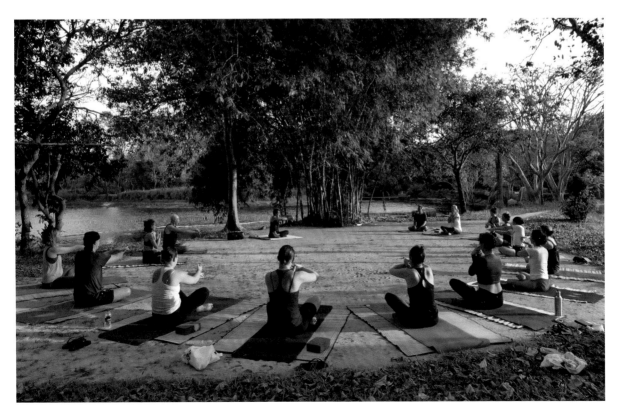

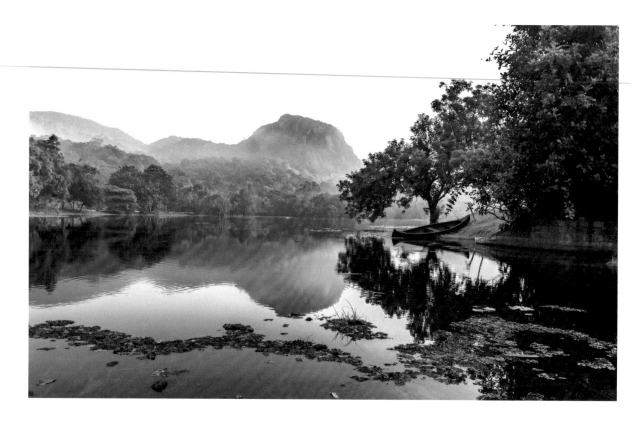

Described as a 'private retreat', Ulpotha offers a minimalist, even rustic lifestyle, with no electricity, internet or alcohol. Expect to find lantern lighting, open-air showers, accommodation in huts without doors or locks, thieving monkeys, reptiles and lots of insects. Ulpotha is clearly not comparable to the other destinations in this book but it has its own unique charm.

If you're expecting to be pampered in a five-star resort with poolside cocktails, this retreat is not for you. But if you're looking for an antidote to the stress of city life, true authenticity and an unforgettable experience, then head for Ulpotha.

It's stylish, peaceful beyond belief and a refreshing, human experience: the community also runs a free Ayurveda clinic for the local villagers and supports local temples, shrines, schools, hospitals and water-management schemes.

On arrival, guests undergo a consultation with the resident Ayurvedic doctor after which the yoga courses (held in a pagoda on the edge of the rice fields) can begin. Beginners and teachers from all over the world come to attend Hatha, Ashtanga or Iyengar yoga classes, which are often given by big international names (Alex Onfroy and Mika de Brito, among others). Vegetarian feasts are served communally, and the rest of the day can be spent bathing among the lotuses in the silky-smooth lake or exploring by bicycle.

In this little corner of paradise, you can truly disconnect and live at nature's pace, with only the sound of the jungle in the background. The ecovillage has a limited capacity of 20 guests, and the very reasonable price (around €1,000 a week) includes accommodation, meals, snacks and drinks, two yoga classes a day, a massage, guided walks in the forest and an excursion.

There's a wonderful room on the waterfront and another high up in a tree (at around 15 metres), but these need to be booked in advance.

© HASSELBLAD H6D

SURYA LANKA AYURVEDA RETREAT

SRI LANKA

PANCHAKARMA TREATMENT
ON A HIDDEN BEACH

This is one of Sri Lanka's first wellness centres to be open to foreigners. Founded in the mid-1990s, it never fails to live up to its excellent reputation.

The Surya Lanka Ayurveda Retreat is a landmark for all those seeking an authentic holistic retreat and a deep journey to the heart of the age-old healing traditions of Ayurveda. The lush tropical setting, the golden sandy beach (Talalla) – considered to be one of the country's most peaceful – and the palm trees swaying gently in the breeze all contribute to a sense of disconnection. Likewise, the architecture, which fits perfectly into the natural landscape, is both soothing and an invitation to engage with the environment.

 SURYA LANKA AYURVEDA RETREAT

+94 112 667 039

suryalanka.com
reservations@suryalanka.com

© AMI ELSIUS

243

The accommodation is designed along Ayurvedic principles and with comfort in mind. Traditional Sri Lankan decoration and a balcony with a breathtaking view of the Indian Ocean to reconnect with nature and its healing power await the guests.

Treatments are personalised according to each guest's dosha (specific constitution) and health goals. However, they all revolve around the famous Panchakarma treatment: an alternative method (still not widely known in the West) that does a deep detox of the body and can potentially even cure certain chronic illnesses.

Panchakarma (from *pancha*, 'five', and *karma*, 'action') alternates cleansing, enemas and treatments based on plants and aromatic oils. To achieve results, it must last a minimum of three weeks.

The Surya Lanka Ayurveda Retreat offers three programmes: the Ayurveda Light programme for a thorough wellness detox, the Ayurveda Intensive programme for a complete body treatment (this one is the most popular and costs around €100 a day) and the Ayurveda Healing programme for people who suffer from illnesses (arthritis, asthma, psoriasis, burn-out, etc.) and require more intense and specific treatments.

Dietary advice, daily yoga and meditation sessions, guided nature walks, cultural excursions and workshops on Ayurvedic principles are also available to enable participants not only to enjoy but also to understand the local culture.

© HAMISH JOHN APPLEBY

CHIVA SOM

QATAR AND THAILAND

THE WORLD'S MOST AWARDED HOLISTIC CENTRE

Is it really necessary to introduce Chiva-Som, one of the most sought-after holistic centres in Asia? This world-renowned symbol of health and wellbeing has repeatedly received press accolades and been praised by celebrities for the quality of its comprehensive menu of treatments and its five-star service (on average, there are four employees for every customer).

In 2022 this temple of well-being in Hua Hin, Thailand, opened an address in Qatar. The wellness resort's first international outpost is located on the shores of the turquoise waters of the Persian Gulf, one and a half hours from Doha.

 CHIVA SOM

chivasom.com

reservations@chivasom.com (Thailand)
reservations@zula.com (Qatar)

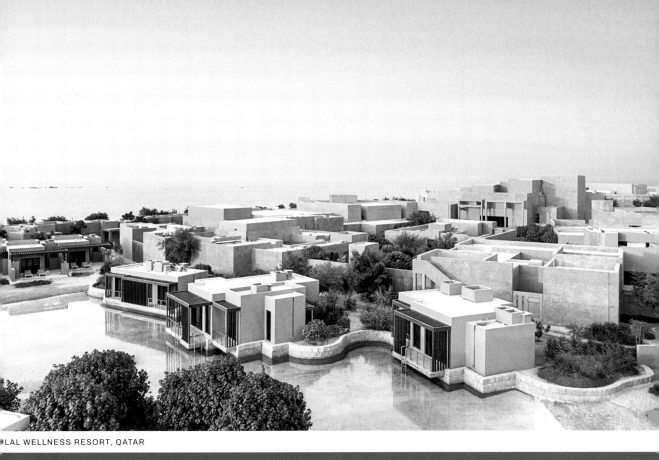

LAL WELLNESS RESORT, QATAR

ZULAL WELLNESS RESORT, QATAR

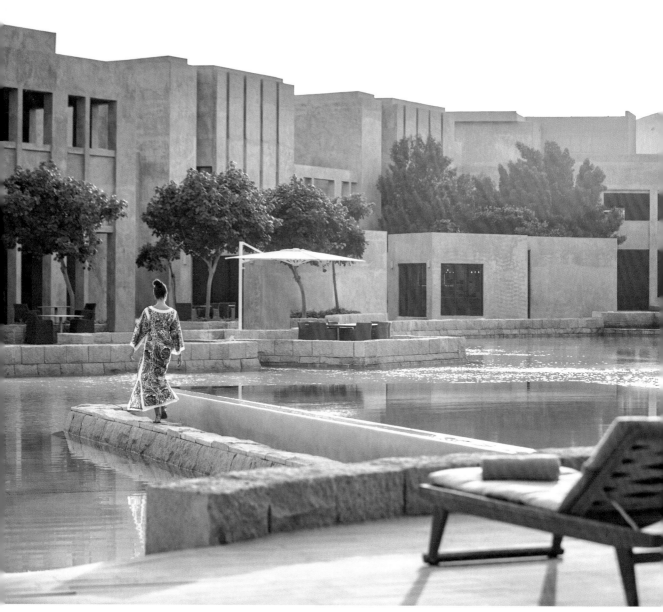

ZULAL WELLNESS RESORT, QATAR

When arriving at Zulal Wellness Resort (Qatar), the first impressions are of a total immersion in nature. Zulal, meaning 'pure water', is a desert-like oasis with courtyard gardens and an abundance of water features.

Just as in Thailand, the retreats last between three and fourteen days and focus on issues like weight loss, wellbeing of body and mind, therapeutic cleansing and anti-ageing. This centre is the Middle East's first destination dedicated to wellbeing.

Retreats begin with a battery of tests (genomics, blood analysis, posturology and more) and a consultation to draw up each guest's personalised programme. Phones, screens and cameras are banned outside the rooms. A retreat at Chiva-Som is no ordinary holiday and requires a minimum of personal commitment.

A full team of specialists and practitioners is always on hand to help you 'change your life', or at least live it to the full, with sports, treatments (physiotherapy, spa and beauty treatments such as laser, salt chamber, etc.), workshops (nutrition, meditation, yoga) and even lectures on the world's challenges in terms of biodiversity and sustainability.

The combination of Asian wisdom, traditional Arab medicine and modern healthcare explains the centre's three-part logo symbolising head, body and mind.

One notable detail is that the resort has an entire section specially designed for families: the Zulal Discovery offers 'family wellness retreats' with activities for all, including kayaking, dance, arts and crafts, and spa treatments even for children.

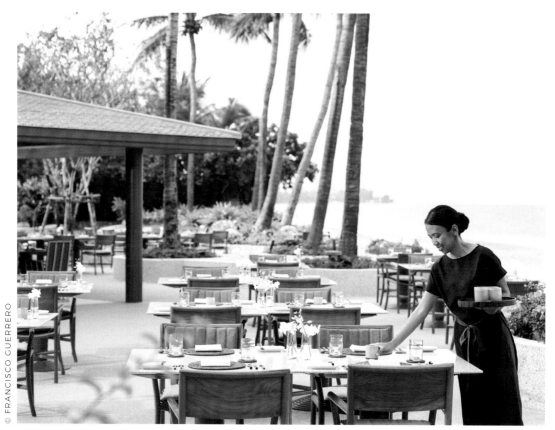

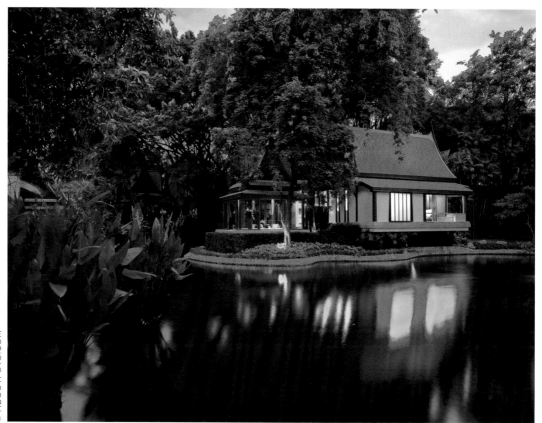

© FRANCISCO GUERRERO

CHIVA SOM THAILAND

© ABOUTFOTO.COM

CHIVA SOM THAILAND

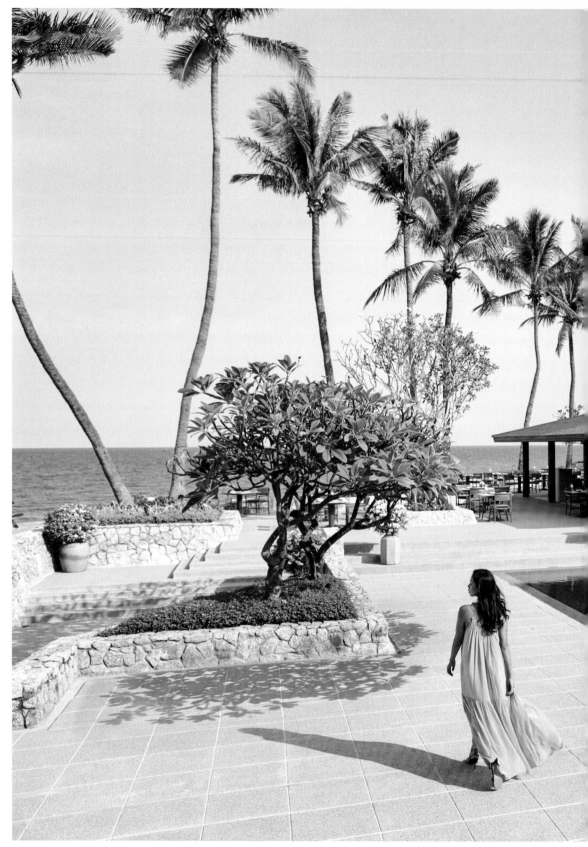

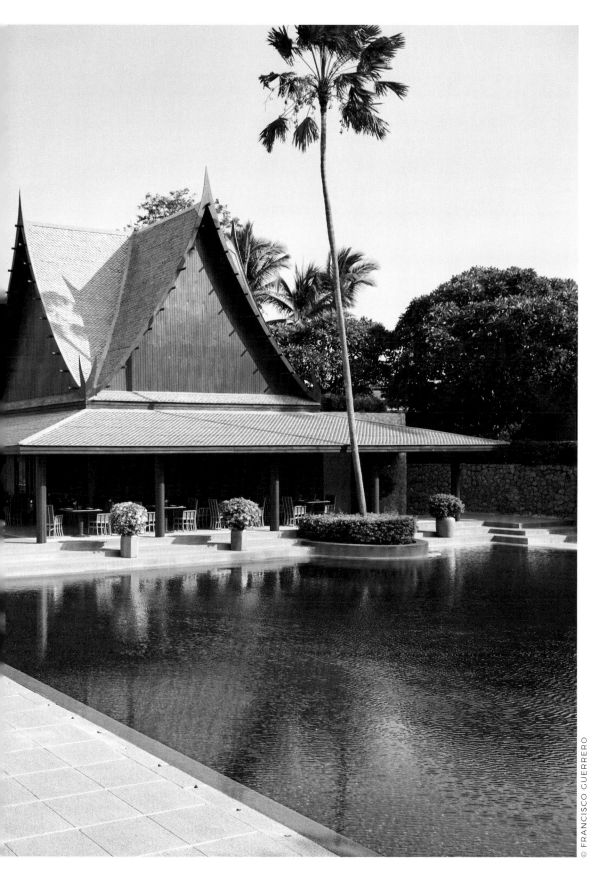

© FRANCISCO GUERRERO

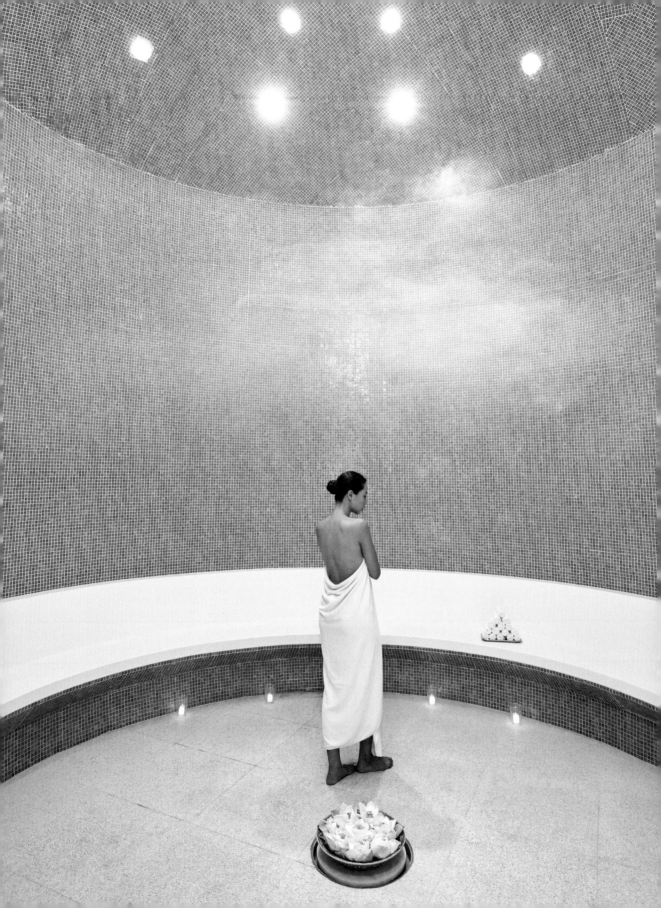

CHIVA SOM THAILAND

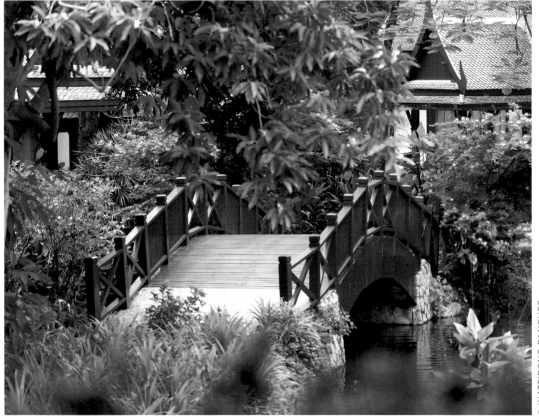

© KIATTIPONG PANCHEE

257

A GARDEN
OF MINDFULNESS

Between Buddhist temples, local healers and Thai massage parlours, Chang Mai has become a yoga town as well as an increasingly popular destination. To get away from the local clichés of wellness tourism, simply head a little further south to the small village of Ban Si Bunreuang, where you'll find Suan Sati, literally the 'garden of mindfulness'.

Amidst lakes, rice paddies and forests, this eco-friendly centre in the heart of the countryside offers five-night yoga and meditation retreats from October to February.

**SUAN
SATI**

+66 (0)91 076 4970

suansati.com
info@suansati.com

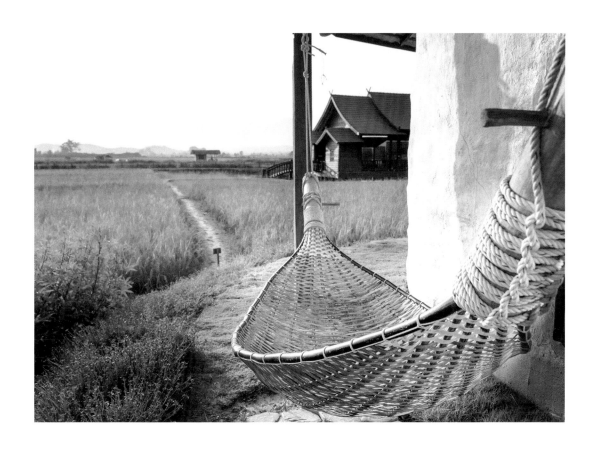

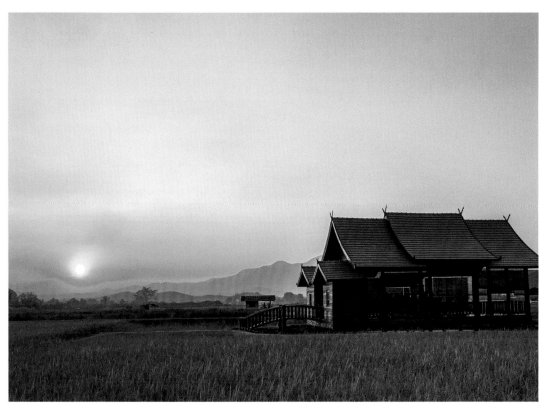

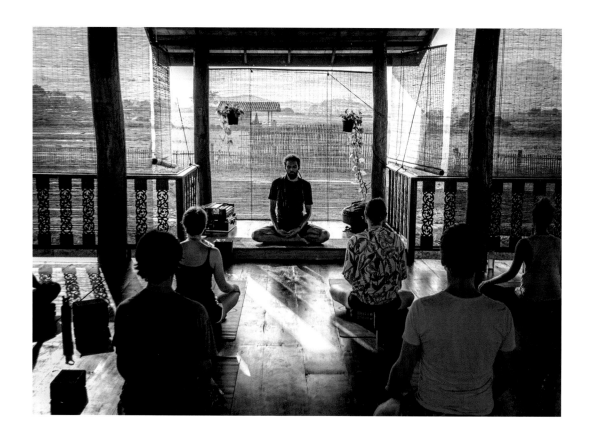

Whether you're a beginner or a seasoned practitioner, Suan Sati welcomes guests looking to improve their yoga practice while watching the sun dip behind the surrounding mountains. The programme includes breathing techniques (anapanasati), meditation sessions and intensive yoga classes as well as a number of extra activities such as an alignment workshop, cooking lessons, singing circles and Wim Hof breathing sessions.

The community insists on inclusivity and makes a point of welcoming every participant with open arms, regardless of their level of practice.

Everyone is encouraged to switch off their mobile phones although the staff can provide a connection in case of emergencies. Some people may be uncomfortable about being 'disconnected' for a few days but most guests welcome this practice and leave positive comments about it at the end of their stay.

A digital detox allows you to connect more deeply with yourself and the other participants, and to be more focused on the programme.

The retreat attracts guests looking for an authentic yoga centre at very affordable prices. Depending on the accommodation option – shared dormitories, shared bungalows or private rooms – a week can cost between €300 and €500. This includes three meals a day, with plenty of vegan dishes that leave guests with fond memories. If you're looking to recharge your batteries and detox from the digital world, this is the place to be.

KAMALAYA WELLNESS RESORT

KOH SAMUI, THAILAND

A FIVE STAR
THAI CLINIC

On the south coast of Koh Samui, among coconut trees and surrounded by white sandy beaches, lies the Kamalaya Wellness Resort ('Kamalaya' translates as 'Lotus Realm'). Built around a grotto where you can come and meditate like Buddhist monks once used to do, the complex of 76 rooms and villas blends in beautifully with the lush vegetation, the cascading streams and the endless private beach ... already a wellness experience in itself.

The resort was founded in 2005 by former Buddhist monk and gallery owner John Stewart and his wife Karina, after years of living a spiritual life in Kathmandu, Nepal. Since then, this holistic establishment has forged a solid reputation in Asia for the quality of its retreats and treatments.

 KAMALAYA WELLNESS RESORT

+66 77 429 800

kamalaya.com
reservations@kamalaya.com

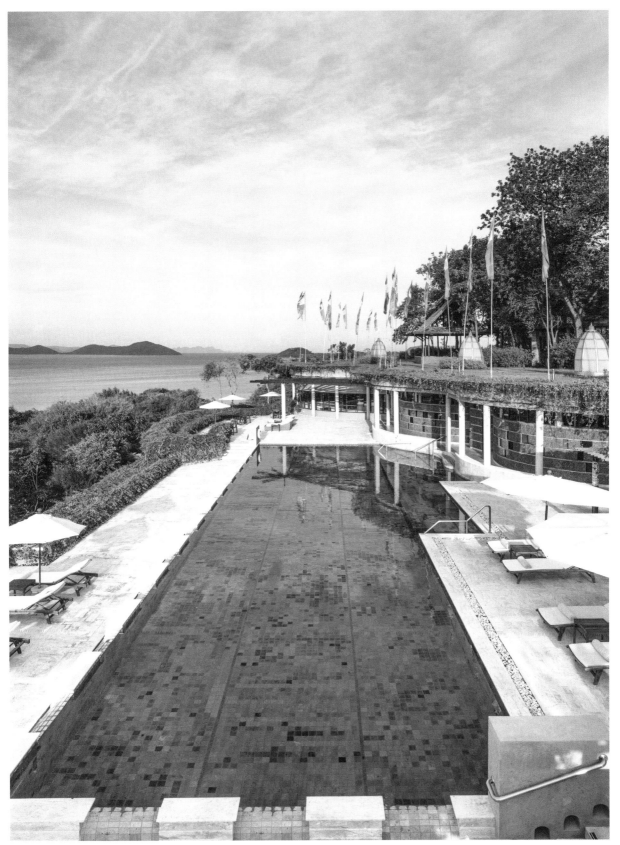

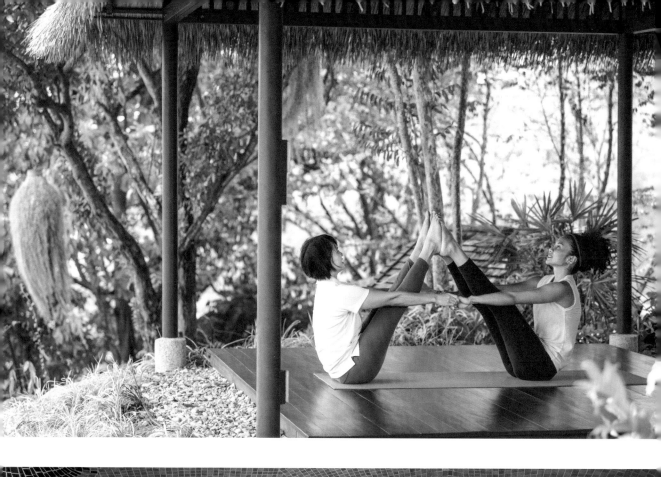

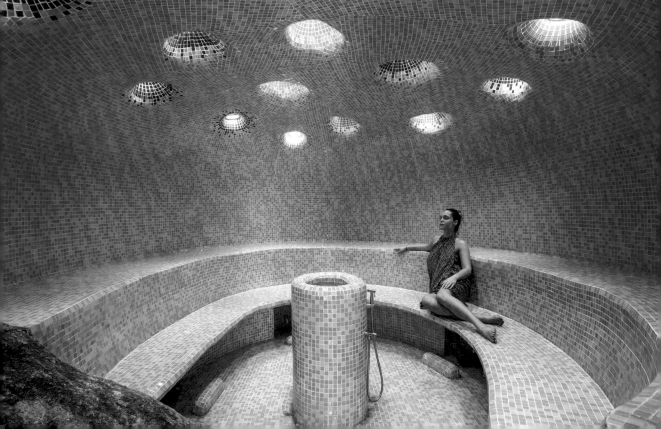

The resort runs wellness programmes lasting either three, five or seven days. With the surrounding nature, and above all the resort's holistic approach to health which combines Eastern and Western traditions, visitors are certain to rediscover their sense of wellbeing. The surroundings may be heavenly, but the resort's *raison d'être* is the menu of retreats on offer, backed up by no fewer than 70 therapies and treatments designed to restore overall balance.

From programmes devoted to detox and reset, stress and burn-out, women's health, weight loss, sleep problems, emotional balance and even a three-week *Wellbeing Sabbatical*, there's something for everyone.

After an initial consultation and health check upon arrival, each guest receives daily support from a team of naturopaths, doctors of Chinese medicine, nutritionists, transformation mentors, Ayurvedic therapists and other fitness and yoga professionals.

As for Kalamaya's cuisine, it's influenced by the need for cellular detoxification and places great emphasis on using local ingredients. Here, it's believed that food is the best medicine: what we eat has a considerable influence on our physical, mental and emotional health.

The decor of the rooms and suites is inspired by traditional Thai dwellings (red wood, coconut trees) and Buddhist monasteries.

This is a luxury wellness retreat for anyone wanting to disconnect from the world and recharge their batteries without foregoing comfort.

© RALF TOOTEN

© RALF TOOTEN

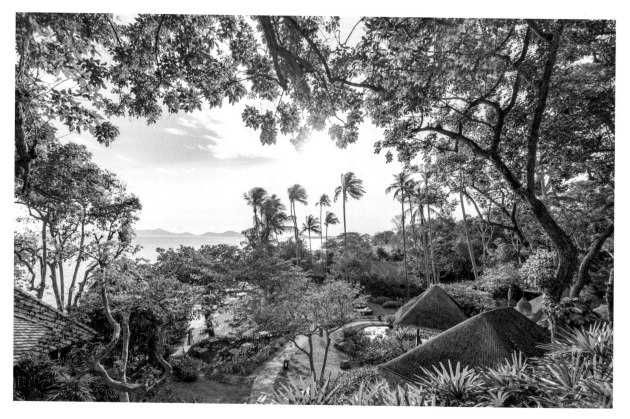

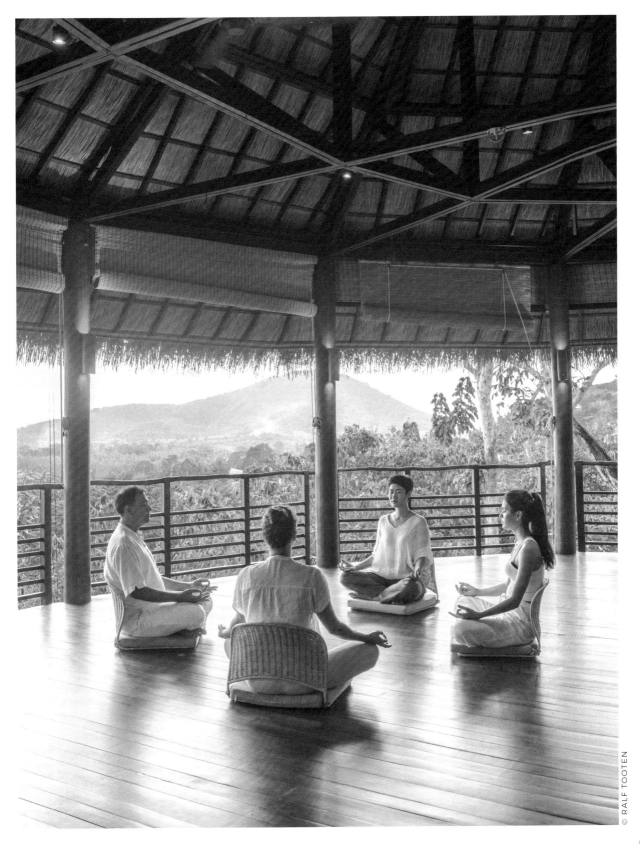

© RALF TOOTEN

COMO SHAMBHALA ESTATE

BALI, INDONESIA

EAT, PRAY AND LOVE IN BALI

It's often referred to as the 'Island of the Gods'. The setting is ideal for self-help books (like Laurent Gounelle's excellent *The Man Who Wanted to Be Happy*) and for the hit film *Eat Pray Love*, starring Julia Roberts as author Elizabeth Gilbert. Bali is an essential stop on the journey of self-discovery and the Como Shambhala Estate is its epicentre.

 COMO SHAMBHALA ESTATE

+62 361 978 888

comohotels.com/bali/como-shambhala-estate
CSestate@comohotels.com

PHOTOS © MARTIN MORRELL

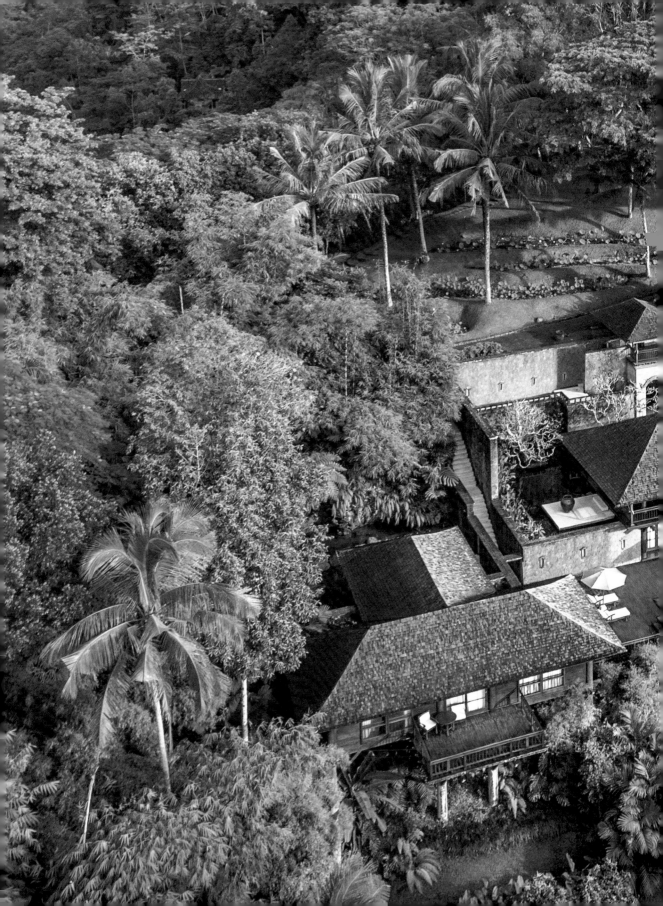

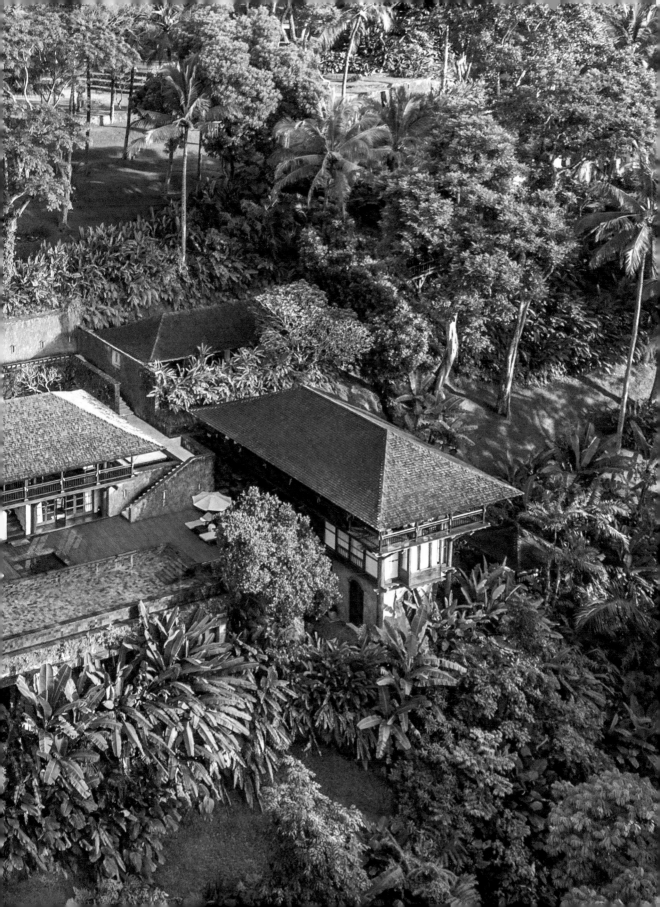

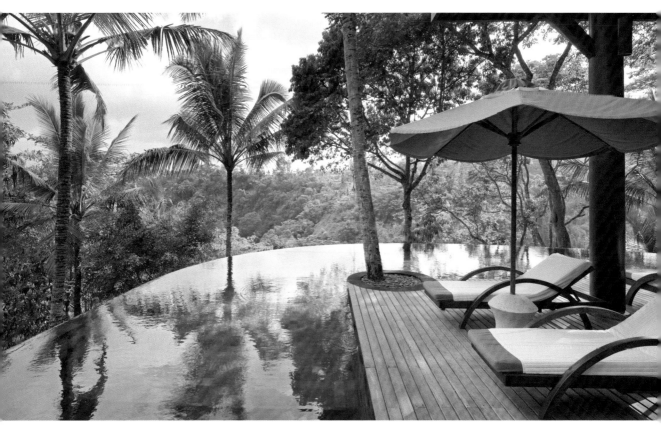

Imagine the very best in design, with semi-open-plan bathrooms and infinity pools, set high above the village of Payangan in the lush jungle of Ubud. Add a holistic approach that combines yoga, meditation, relaxation exercises and spa treatments. Sprinkle in delicious raw, plant-based meals (or heated to temperatures that remain below 40–45 degrees Celsius) to be as high in vitamins, enzymes and minerals as possible – here, cow's milk is replaced by nut milk and processed sugars by honey.

The aim of a raw food diet is to preserve the nutritional value and vitality of the ingredients, as certain nutrients lose their potency and effectiveness when they are heated at high temperatures. It's the case with folic acid, for example.

Como Shambhala is a magical retreat, regularly voted best spa in the world. It offers made-to-measure programmes that evolve according to the season (there's a New Year Renewal programme, for example). The list of treatments is long (and mouth-watering!): local massages (the famous local Taksu massage, but also Indian head massage, Thai massage, reflexology, etc.), acupuncture, colon hydrotherapy, hyperbaric oxygen therapy (oxygen is supplied in a hyperbaric room similar to a diving chamber), mud and local plant treatments, Ayurvedic cures, Pilates classes, Qigong, walks in the rice fields, purification rituals using Balinese spring water, picnics in the estate's hidden jungle garden or an invitation to a traditional offering ceremony …

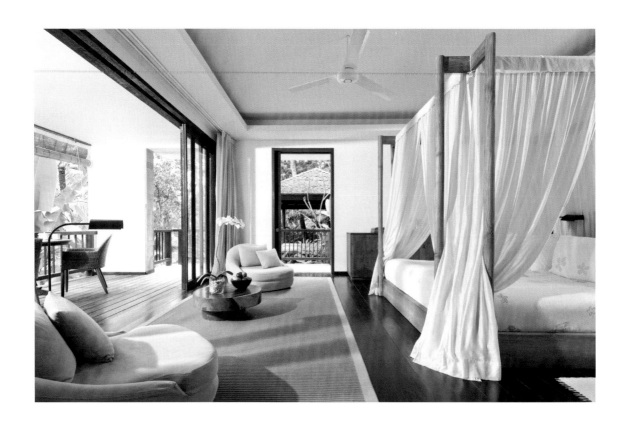

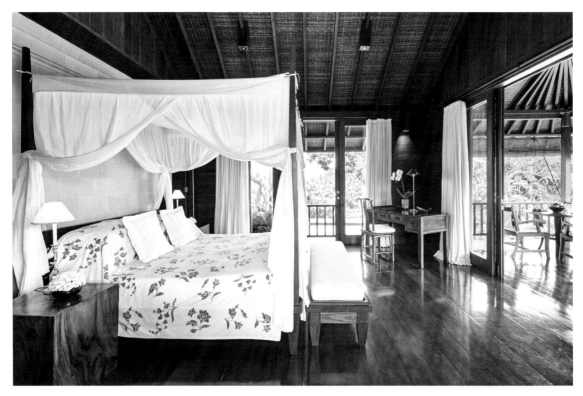

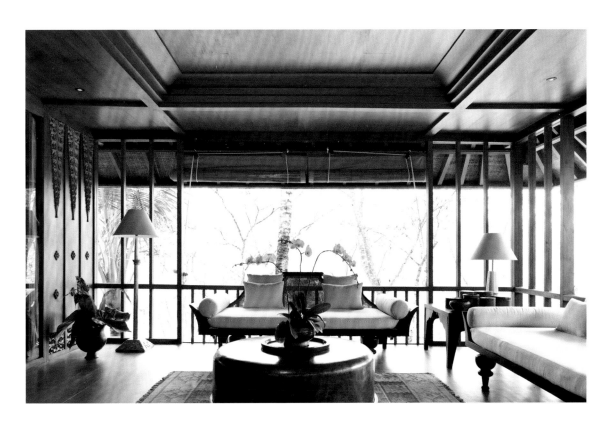

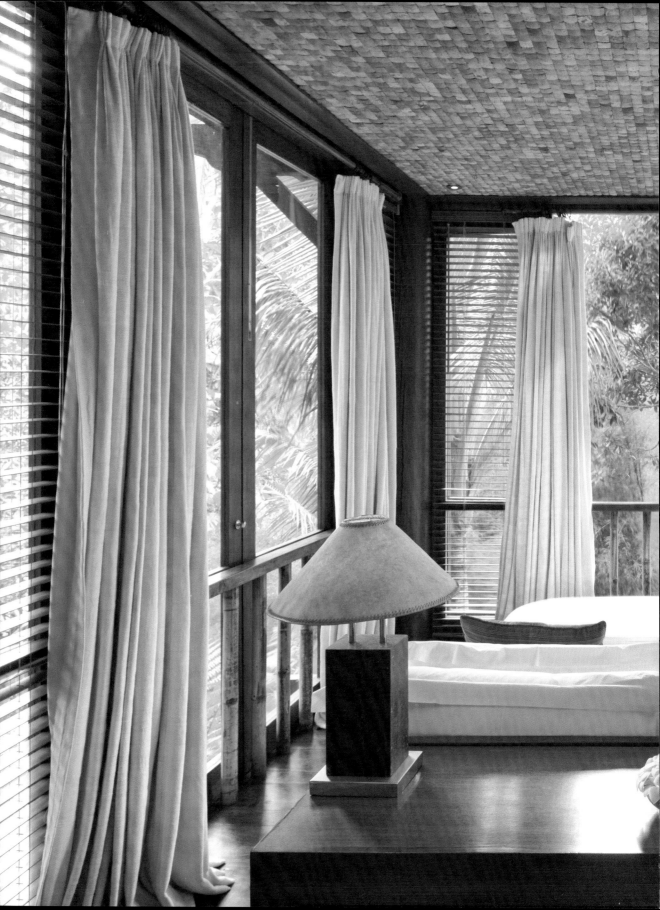

Index

ABOUT THE AUTHOR

© NOELLI BROOHM

Émilie Veyretout is the former head of the beauty and wellness section of the French newspaper *Le Figaro*. She has spent ten years travelling, exploring and decoding these overlapping sectors for the most demanding readers. In 2022 she co-founded PLEACE, a platform of videos featuring a selection of the best disciplines (yoga, dance, meditation, hypnosis and more) and experts to create a mini wellness retreat at home (pleace.fr). She is also a consultant for major brands such as Dior, Lancôme and Shiseido.

THANK YOU,

Simon, Sasha and Alie, my fellow travellers.
Carole and Elia, for being by my side throughout the writing process.
My journalist friends, my friends in general (especially Vicky) and press agents who gave me their (best) leads.
Thomas, for seeking me out and presenting me with this (new) challenge.

Last, but not least, you who are holding this book, readers, seekers of wellbeing, resort directors and distributors, thank you for your confidence.

PHOTO CREDITS

p. 9, 10, Mii Amo © Mii Amo; p. 12–13, Mii Amo © Ken Hayden Photography – p.14, 17, Esalen Institute © Esalen Institute – p. 18–23, Blue Spirit © Blue Spirit – p. 25–29, Finca Victoria © Finca Victoria – p. 30, 34–35, 37, Arctic Bath © Arctic Bath; p. 33, Arctic Bath © Viggo Lundberg; p. 36 (image above), Arctic Bath © Malin Sax Photography FD Sweden Wedding Photography; p. 36 (image below), Arctic Bath © Pasquale Baseotto – p. 39, p. 40 (image above), p. 41, Buchinger Wilhelmi © Winfried Heinze; p. 42 (image above), Buchinger Wilhelmi © B.Lateral GMBH&&CO.KG WH; p. 40, 42 (image below), 44–45, Buchinger Wilhelmi © Buchinger Wilhelmi – p. 46, 51 (image above), 52 (image above), 54–55, Lanserhof Sylt © Lanserhof; p. 48–49, 52 (image below), 53 (image above), Lanserhof Sylt © Ingenhoven Architects; p. 51 (image below), Lanserhof Sylt © Alexander Haiden; p. 53 (image below), Lanserhof Sylt © Sandra – Stock Adobe.com – p. 57, 60–61, Vivamayr © Vivamayr; p. 58, Vivamayr © Koenigshofer Michael – p. 62, 64, 65, 67, Château du Launay © Château du Launay; p. 68–69, Château du Launay © Benjamin Sellier – p. 71–75, L'Arbre qui marche © L'Arbre qui marche – p. 80 (image below), Les Tilleuls Étretat © Les Tilleuls Étretat; p. 77, 78–79, 82–83, Les Tilleuls Étretat © Frenchie Cristogatin; p. 80 (image above), Les Tilleuls Étretat © Jörg Braukmann; p. 84–85, © Nicoleon – p. 87, Tapovan © Tapovan; p. 88, Tapovan © 1996–98 Accusoft Inc., All Right – p. 90 (image above), La Pensée Sauvage © La Pensée Sauvage; p. 90 (image below), La Pensée Sauvage © Aurélie Lamour; p. 93, La Pensée Sauvage © Microgen@mail.com; p. 92–93, La Pensée Sauvage © Photographie Camille Moirenc – p. 96–103, Lily of the Valley © November Studio – p. 104, 109, Sublime Comporta © Ricardo Santos; p. 107, 108 (image above), 110–111, Sublime Comporta © Nelson Garrido; p. 108 (image below), Sublime Comporta © Lisa and Sven Photography – p. 112, 115, 116–117, Sha Wellness Clinic © Antonio Terron – p.118, 124 (image above), 125, 126–127, Six Senses © Six Senses; p. 120–121, 124 (image below), Six Senses © Assaf Pinchuk Photographer Apinchuk.com – p. 128–139, Forestis © Forestis – p. 140–145, Palace Merano © Altea Software SRL. Marco Sartor – p. 146–151, Eremito Hotelito del Alma © Marco Ravasini – p. 153 (image above left), Casa di Sale © Picasa; p. 153 (image above right), Casa di Sale © Casa di Sale; p. 153 (image below), 154, Casa di Sale © Paolo Beccari – p. 156–167, Silver Island Yoga © Silver Island Yoga; p. 161 (image above right), Silver Island Yoga © Jack Fillery; p. 163 (image above), Silver Island Yoga © George Fakaros; p. 165 (image below), Silver Island Yoga © Fiona E. Campbell – p. 168, 170–171, 174 (image above), 175, 176–177, Euphoria Retreat © Stavros Habakis; p. 173 (image above), Euphoria Retreat © Margarita Nikitaki 2018; p. 173 (image below), 174 (image below), 178–179, Euphoria Retreat © Euphoria Retreat – p. 181 (image above), TheLifeCo © Emre Gologlu; p. 181 (image below), 182 (image above), TheLifeCo © TheLifeCo; p. 182 (image below), TheLifeCo © Larien Dijital Medya / Zeyner Isik – p. 184–187, The Yogi Surfer © Fabrice Coiffard – p. 189, 196–197, Bliss & Stars © Bliss & Stars; p. 190–191, 192, 194, 195, Bliss & Stars © Teagan Cunniffe – p. 198–209, Joali Being © Joali Being – p. 210, 213, Somatheeram Ayurvedic Health Resort © Benjamin Kurtz; p. 212, 215, 216–217, 218, 219, Somatheeram Ayurvedic Health Resort © Somatheeram Ayurvedic Health Resort – p. 221, 222–223, 224 (image below), 226–227, 228 (image above), 229 (image above), 230–231, Ananda © Ananda; p. 224 (image above), Ananda © Roso Photography; p. 228 (image below), Ananda © Latitude Photography; p. 229 (image below), Ananda © Chris Caldicott – p. 233, 234, 235 (image below), 236, 238–239, 240 (image below), 241, Ulpotha © Ulpotha; p. 235 (image above), Ananda © Peter Blaesild for Ulpotha; p. 240 (image above), Ulpotha © Hasselblad H6D – p. 243 (image above), 245 (image below), Surya Lanka Ayurveda Retreat © Surya Lanka Ayurveda Retreat; p. 243 (image below), Surya Lanka Ayurveda Retreat © Ami Elsius; p. 245 (image above), Surya Lanka Ayurveda Retreat © Hamish John Appleby – p. 247 (image above), 248–249, 250, 253, 256, 257 (image above), Chiva Som © Chiva Som; p. 247 (image below), Chiva Som © Antoniosaba; p. 252 (image above), 254–255, Chiva Som © Francisco Guerrero; p. 252 (image below), Chiva Som © Aboutfoto.com; p. 257 (image below), Chiva Som © Kiattipong Panchee – p. 259, 260, Suan Sati © Suan Sati – p. 263, 264 (below), 268 (image below), Kamalaya Wellness Resort © Kamalaya Wellness Resort; p. 264 (image above), 266–267, 268 (image above), 269, Kamalaya Wellness Resort © Ralf Tooten – p. 271–279, Como Shambhala Estate © Martin Morrell.

This book was created by:

Émilie Veyretout, author

Emmanuelle Willard Toulemonde, layout

Olivia Fuller, translator

Jana Gough, editing

Kimberly Bess, proofreading

Roberto Sassi, publishing manager

Atlas

Atlas of extreme weather
Atlas of geographical curiosities
Atlas of unusual wines

Photo books

Abandoned America
Abandoned Asylums
Abandoned Australia
Abandoned Belgium
Abandoned Churches: Unclaimed places of worship
Abandoned cinemas of the world
Abandoned France
Abandoned Germany
Abandoned Italy
Abandoned Japan
Abandoned Lebanon
Abandoned Spain
Abandoned USSR
After the Final Curtain – The Fall of the American Movie Theater
After the Final Curtain – America's Abandoned Theaters
Baikonur – Vestiges of the Soviet space programme
Cinemas – A French heritage
Forbidden France
Forbidden Places – Vol. 1
Forbidden Places – Vol. 2
Forbidden Places – Vol. 3
Forgotten Heritage
Oblivion
Secret sacred sites
Venice deserted
Venice from the skies

'Soul of' guides

Soul of Amsterdam
Soul of Athens
Soul of Barcelona
Soul of Berlin
Soul of Kyoto
Soul of Lisbon
Soul of Los Angeles
Soul of Marrakesh
Soul of New York
Soul of Rome
Soul of Tokyo

PUBLISHER

'Secret' guides

Secret Amsterdam
Secret Bali – An unusual guide
Secret Bangkok
Secret Barcelona
Secret Bath – An unusual guide
Secret Belfast
Secret Berlin
Secret Boston – An unusual guide
Secret Brighton – An unusual guide
Secret Brooklyn
Secret Brussels
Secret Budapest
Secret Buenos Aires
Secret Campania
Secret Cape Town
Secret Copenhagen
Secret Corsica
Secret Dolomites
Secret Dublin – An unusual guide
Secret Edinburgh – An unusual guide
Secret Florence
Secret French Riviera
Secret Geneva
Secret Glasgow
Secret Granada
Secret Helsinki
Secret Johannesburg
Secret Lisbon
Secret Liverpool – An unusual guide
Secret London – An unusual guide
Secret London – Unusual bars & restaurants
Secret Los Angeles
Secret Louisiana – An unusual guide
Secret Madrid
Secret Mexico City
Secret Milan
Secret Montreal – An unusual guide
Secret Naples

Secret New Orleans
Secret New York – An unusual guide
Secret New York – Curious activities
Secret New York – Hidden bars & restaurants
Secret Normandy
Secret Prague
Secret Provence
Secret Rio
Secret Rome
Secret Seville
Secret Singapore
Secret Stockholm
Secret Sussex – An unusual guide
Secret Tokyo
Secret Tuscany
Secret Venice
Secret Vienna
Secret Washington D.C.
Secret York – An unusual guide

Follow us on Facebook, Instagram and X

In accordance with regularly upheld French jurisprudence (Toulouse 14-01-1887), the publisher will not be deemed responsible for any involuntary errors or omissions that may subsist in this guide despite our diligence and verifications by the editorial staff. Any reproduction of the content, or part of the content, of this book by whatever means is forbidden without prior authorization by the publisher.

© JONGLEZ 2024
Registration of copyright: May 2024 – Edition: 01
ISBN: 978-2-36195-768-1
Printed in Slovakia by Polygraf